# A–Z

OF

# BARNSTAPLE

PLACES – PEOPLE – HISTORY

# Denise Holton & Elizabeth J. Hammett

AMBERLEY

First published 2018

Amberley Publishing
The Hill, Stroud, Gloucestershire, GL5 4EP
www.amberley-books.com

ISBN  978 1 4456 7775 0 (print)
ISBN  978 1 4456 7776 7 (ebook)

British Library Cataloguing in Publication Data.
A catalogue record for this book is available
from the British Library.

Origination by Amberley Publishing.
Printed in Great Britain.

# Contents

Introduction    6

Abbot – A Family of Plaster Workers    7
Abyssinia Terrace    7
Albert Clock    7
Angel Hotel    8
Appledore    9
Apsley, Allen and James    9
Archaeological Excavations    9
Athenaeum    10

Baller, Joseph    11
Baller, Katherine    11
Barnstaple Baise    11
Barre, Simon de la    12
Barum    12
Beaple, Grace    12
Beaple, Richard    12
Bear/Barre Street    13
Bencraft, Lionel    14
Blake, Martin    14
Boutport Street    14
Brannam's Pottery    15
Brannoc, St    15
Bridge Chambers    16
Bridge Trust    17
Burhwitan    18
Butcher's Row    18

Castle    19
Castle House    19
Chanters Green    20
Chapman, Robert    21
Chichester Family    21
Chichester, Sir Francis    22
Chivenor    23
Cholera    24
Civil War    24
Codden Hill    24
Coney Gut    25
Congregational Churches    25

Corn Exchange    26
Corruption in Politics    26
Cross/Crock Street    27
Cyprus Island (also known as
   Monkey Island)    27

Delbridge, John    28
Derby    28
Dodderidge, Dorcas    28
Dodderidge, John
   (son of Pentecost)    29
Dodderidge, Richard
   and Pentecost    29
Domesday Book    30
Dornats    30

Eadwig    31
Ebberley Lawn    31
Ebrington    31
Electricity Station    32
Elephant Lane    32

Fair    33
Floods    34
Food Riots    34
Fortescue Family of Filleigh    35
Funeral, Charles Sweet Willshire    35

Gay, John    37
Golden Lion    38
Gould, R. D.    38
Grammar School    39
Guildhalls    40

Hankford, Thomasia    41
Hanmer, John and John    41
Harper, Sydney    42
Hodgson, Frederick    42
Holt Trinity Church    43
Horwood, Almshouses
   and School    43

Hospitals, NDI replaced
    by NDDH                       44
Huguenots                        44
Imperial Hotel                   45

Incledon, Benjamin               46
Instow                           46

*Jeremiah*                       47
Jewell, Harriette Ellen          47
Jewell, John                     48
John Gay Theatre                 48
Joy Street                       49
Juhel                            49

Kilns                            50
Knapp House                      51
Knight, R. L.                    51

Lace Industry                    52
Lauder, Alexander                53
Lee, Frederick Richard           53
Lethaby, William Richard         54
Litchdon Street                  55
Literary and Scientific
    Institution                  55

Maiden Street                    56
Market Street                    56
Market, Pannier                  56
Mazzards                         57
Millenary Stone                  58
Mint                             58

Newport                          59
North Devon School               60
North Walk                       60
Northgate                        61

Oliver, Bruce                    62
Organ                            62

Palmer, William                  63

Parish Church                    64
Park Lane                        65
Paternoster Row                  65
Pearces Restaurant               66
Peard, George                    67
Penrose, John                    67
Pewter and Pewterers             69
Pilton                           69
Pipes and Pipemakers             70
Post Offices                     70
Potters Lane                     71
Public Houses                    71

Quay Station                     72
Queen Anne's Walk                72
Queen Street                     73
Quick Family                     73

Raleigh                          74
Rawle, Gammon and
    Baker (RGB)                  74
Rock, W. F.                      75
Rolle Street                     75
Rolle, Mark                      75
Royal Visits                     76
Russell, Revd Jack               77

Shapland and Petter              78
Southgate                        79
St Anne's Chapel                 79
*Stevenstone*, HMS               80
Sticklepath                      80
Swan Inn                         81

Taw Vale                         82
Theatre/Theatre Lane             82
Tome Stone                       83
Tourism                          83
Trinity Street                   83
Tuly Street                      85
Tunnels                          85
Turner, Joseph
    Mallord William              85

| | | | |
|---|---|---|---|
| Turnpike Centre Stone | 86 | X-Ray Machine | 92 |
| *Unicorn* | 87 | Yarn Beam | 93 |
| Union Workhouse | 87 | Yeo | 93 |
| Vicarage Lane | 88 | Youings, Professor Joyce | 93 |
| Victoria Chambers | 88 | | |
| Victoria Road | 89 | Zenaxis, No. 7 The Strand | 94 |
| Victorian Postboxes | 89 | Zeppelin | 95 |
| | | Zion Place | 95 |
| Well Street | 90 | | |
| West Gate | 90 | Bibliography | 96 |
| Westacott's Shipyards | 91 | | |
| Wyatt, Adam | 91 | | |

# Introduction

By AD 930 the basic layout of Barnstaple was already in place, with Boutport Street and the High Street in existence and a strong defensive wall surrounding the town. One of King Alfred's four 'burhs', Barnstaple was allowed to mint coins. Its old name 'Bearde Staple' is believed to mean the market or staple of Bearda.

By 1066 Barnstaple was a well-established town, and twenty years later was mentioned in the Domesday Book. The king held the borough of Barnstaple for himself and it was not until Henry I came to the throne that the first Lord of Barnstaple, Judhael of Totnes, was created. It was Judhael who founded the priory of St Mary Magdalene in 1107 outside the town wall.

By 1290 Barnstaple had become an important trading centre, in particular for wool and woollen material, and five years later sent two burgesses to represent the town in Parliament.

The late sixteenth and early seventeenth centuries were the most exciting period in Barnstaple's development. The Great Quay was built at this time, making it easier for ships to load and unload goods, leading to a great increase in trade. Tobacco was imported from the New World and pottery, tools, cloth and other goods were exported in return. In 1603, work began on the building of a new quay to cope with the expanding trade.

The year 1642 saw the start of the English Civil War. Barnstaple was first held by the Parliamentarians but changed hands four times before the end of the war. It was in June 1645 that Prince Charles (the future Charles II), on the run from the plague in Bristol, took refuge in the town before moving on in July.

After the war, it has been estimated that it took nearly a century for the town to recover its previous prosperity. In the eighteenth century Barnstaple continued to expand as a port and industrial centre of North Devon. Queen Anne's Walk was created in its present form as a merchants' exchange, and marshy land at the end of the bridge was drained. The year 1710 brought the first proposals to create a formal square. Several roads leading to Barnstaple were repaired and widened after George III passed an Act requiring this work to be carried out.

In 1825, steam was used for the first time in Barnstaple to power lace bobbins at the Derby Mill factory, and a year later the present Guildhall was built. During the first half of the century, the population had doubled to 8,500 and by 1835 the town's boundaries were extended to include Pilton and Newport. In 1854, the Barnstaple to Exeter railway opened.

The continued silting of the River Taw resulted in Barnstaple's port becoming rundown and, as time passed, the major part of the woollen industry moved to other parts of the country with other larger ports taking much of Barnstaple's trade.

The twentieth century, however, saw a gradual resurgence of Barnstaple's fortunes, with several major firms settling in the town at Pottington and Roundswell. As we move further into a new century, Barnstaple continues to flourish as the chief town of North Devon.

In compiling this book, some people and places, though well known to many Barumites, simply had to be included. Such a book would be incomplete without them. However, we hope that we have also included some details, occurrences and individuals that are less well known, and some you may not know about at all.

# A

## Abbot – A Family of Plaster Workers

During the late sixteenth and seventeenth centuries, decorative plaster ceilings became fashionable. Devon's prosperity in the seventeenth century can be seen in the exceptional number of such ceilings in houses great and small. The houses of Barnstaple's wealthy merchants contained many examples, but fashions change, and most were destroyed. Fortunately, the extremely ornate ceiling in the Bank restaurant at the end of Boutport Street has survived. Dated 1620, when the property was a merchant's house (it later became the Golden Lion Inn and then Westminster Bank), it may be an example of the work of John Abbot of Frithelstock.

The decorated ceiling rose in the chapel of Penrose Almshouse may also be his work. The names of the craftsmen are rarely documented, but there was a family at Frithelstock: John Abbot, his son Richard and Richard's son, another John, whose pattern book survives in the Devon Record Office. He was responsible for the royal arms in Frithelstock Church and probably in Meeth Church, and also for a ceiling in the Royal Hotel, Bideford, which was once part of a merchant's house. Probably his most famous work is in the Custom House, Exeter, built 1680–81.

## Abyssinia Terrace

A short terrace of Victorian houses in Newport, Abyssinia Terrace has nothing remarkable about it except its name, which provides a connection with world events and the distant African country of Ethiopia, then known as Abyssinia. On 10 April 1868 the British army was victorious at the Battle of Magdala, capital of Abyssinia. It was a punitive expedition to rescue hostages held captive by the defeated Emperor Tewodros, or Theodore II, who committed suicide. The leader of the expedition was Lieutenant-General Sir Robert Napier, who became a popular hero.

## Albert Clock

The Albert Clock was erected in 1862 and paid for by public subscription. It was the town's memorial to Prince Albert, the husband of Queen Victoria, who had died the previous year. Originally the plan had been to erect a tower but it was suggested that the town needed a clock, so the borough surveyor, R. D. Gould, was asked to alter his design to include a clock face on each of the four sides of his tower design. The eventual cost of the project was £400. Exactly one year later, on 13 December, the mayor and other civic dignitaries assembled at The Square. It had been proposed that

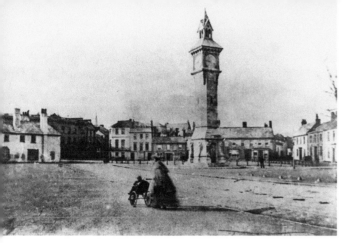

The Albert Clock, erected in memory of Prince Albert.

the clock was to be started at 11 p.m. – the hour that Prince Albert had died – and that there was to be no great ceremony or display, just quiet dignity with the pendulum set to start the clock mechanism.

## Angel Hotel

The Angel was one of Barnstaple's oldest inns. Located on The Strand, it was in existence by 1658 but was probably much older. The inn was known for providing stabling for all types of horses at the fair and other times, but eventually it declined

The Regal Cinema, built on the site of the Angel Hotel.

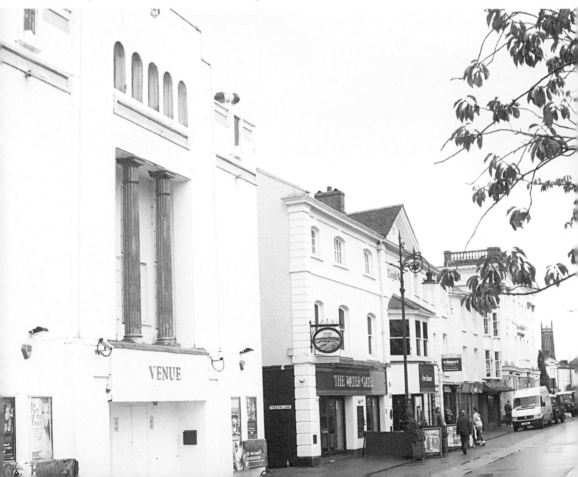

and by 1935 it lay in ruins. In August 1937 the new Regal Cinema opened on the site. A report in the local paper noted that very few antiquities were discovered when the old buildings were being cleared – just a few coins dated around 1700, a very old well said to be Elizabethan, and a Jacobean window in too bad a state of repair to be preserved.

## Appledore

The name Appledore for the village opposite Instow on the Taw and Torridge estuary is first recorded in 1335, but it is almost certainly the place earlier known as Tawmouth. Until 1814 it was part of the port of Barnstaple, but from that date became part of the port of Bideford. Appledore was occupied for Parliament at the beginning of the Civil War, but surrendered to the Royalists in September 1643. Parliamentary forces from Barnstaple besieged the fort in July the following year, but were beaten off by troops sent from Exeter commanded by Sir Allen Apsley.

## Apsley, Allen and James

Sir Allen Apsley was the Royalist governor of Barnstaple from December 1644 until he surrendered the town to the victorious Parliamentarian forces in April 1646. James was his younger brother. According to one report dated March 30 1646, 'It is generally believed that Sir Allen Apsley is willing to surrender the Towne, Fort and Castle, but that his desperate Brother swears he will cut him to peeces if he offers to surrender the Castle.' They were both sons of Sir Allen Apsley, who had been governor of the Tower of London. Their sister was Lucy Hutchinson and was married to the Parliamentarian governor of Nottingham.

## Archaeological Excavations

There have been many archaeological excavations in Barnstaple, usually carried out as a matter of urgency when properties were demolished or altered. In the 1970s Trevor Miles excavated part of Paiges Lane prior to the Marks & Spencer extension, which altered the route of the lane into Holland Street. He found evidence of a row of stone medieval merchants' properties with rubbish pits outside clay-bonded stone walls, and even a stone floor visible in one building. They were probably ground-floor shops or warehouses with living rooms above, dating from 1350–1400. In around 1700 they were converted into five cottages. Further excavations in the 1970s, this time in Joy Street, revealed traces of eleventh-century buildings. The street frontage then only varied by around 12 inches from the present street line.

A major excavation took place in 1972–75 when Trevor Miles investigated part of Castle Green, close to North Walk. This revealed the area had been an Anglo-Saxon cemetery, with over 100 graves being discovered. Examination of the bailey rampart and moat revealed signs of a substantial rampart and a moat that extended below the high watermark and probably joined the waters of the Yeo and Taw. In an early excavation in 1927 on top of the Castle Mound (the 'motte' of the castle), Bruce Oliver uncovered two concentric stone foundations. He also partially sectioned the motte ditch, which revealed it was around 16 metres wide at its top and at least 4.5 metres deep.

An opportunity for extensive archaeological investigation occurred in the 1980s when the old Dornats building in Tuly Street was demolished to make way for the new library and record office. Several properties in Tuly Street and Gammon Lane were also demolished prior to redevelopment of the area. The main discoveries related to seventeenth-century pottery kilns in the area that is now the library car park, which occupied the site when the land around the castle was rented out. Remains of a small kiln dated to around 1290 provided the earliest evidence of pottery production in Barnstaple. A large ditch was revealed, which probably represented an outer defence of the castle. From the thirteenth century this was a trackway and the forerunner of Tuly Street. A few years ago excavations behind the former Exeter Inn in Litchdon Street revealed evidence of sixteenth-century pottery works.

## Athenaeum

Built in 1872 as the private house of Mr William Thorne, he died before moving in and the property was sold to William Rock. When first built, the gardens of the house were enclosed by elaborate railings, but these were removed during the Second World War. The building became the Athenaeum and is now known as the Museum of Barnstaple and North Devon.

The Athenaeum, built as a private house in 1872.

# B

## Baller, Joseph

Joseph Baller was John Gay's nephew, the son of his sister Katherine and her husband Anthony Baller. He was born in 1707 and lived a long life. His burial took place at Barnstaple Parish Church in December 1790, although he was a dissenting minister and for some years he was minister of the Torrington Independent Chapel. He had been chief mourner at the funeral of his uncle John Gay in 1732 at Westminster Abbey as he was the only family mourner in London at the time.

He was married twice, his first wife being Mary Brough, the sister of the treasurer at Guy's Hospital. A few years after her death he married Mary Palmer in Barnstaple in 1761. At the time of his death Joseph Baller had two daughters living: Mary, who had no children and Katherine, who had married Thomas Stiff of London and had several children. Another daughter, Apphia, had predeceased her father, but children from her marriage to Revd John Hogg of Exeter survived. At the time of his death Joseph Baller was a wealthy man, owning properties in High Street, Cross Street, Back Lane and Holland Street. Two gardens in Back Lane (later Queen Street) were bequeathed to his daughter Katherine. One of these was probably the garden in Back Lane, provided by her husband in 1812 (after Katherine's death) for use as a burial ground by the Cross Street Chapel. Her son, Zachariah Carleton Stiff, although born in London is buried in Holy Trinity Churchyard, Barnstaple.

## Baller, Katherine

Katherine Baller, mother of Joseph, was born in 1676 – nine years before her brother, John Gay. In 1706, she married Anthony Baller, a member of the numerous Baller family of Barnstaple, although he was then an apothecary of St Andrews, Holborn. By 1716 Katherine was a widow and returned to Barnstaple with her children. John Gay died intestate and his estate of around £6,000 was inherited by Katherine and her sister Joanna. Her son Joseph Baller was the principal beneficiary of her will, dated 1740, in which she mentions land at Maidenford in the parish of Barnstaple. She also mentions another son, Mark Anthony, and a daughter, Susanna. To her other daughter, Katherine Houndel, she gave her a gold repeating watch and chain with 'the thimbles and other appurtenances thereto'.

## Barnstaple Baise

By the Middle Ages one of the foundations of Barnstaple's wealth was the wool trade and manufacture of woollen cloth. By 1303 there were around 200 members of the

Guild of St Nicholas, founded to protect the interests of all those involved in the wool trade. One of the main items produced was a cloth known as Barnstaple baise. Hardwearing and resilient, it was a coarse worsted cloth known to be long lasting and was one of the town's major exports.

## Barre, Simon de la

Simon de la Barre was the first recorded mayor of Barnstaple in 1301. He was again mayor in 1310–11. From the thirteenth century, the de la Barre family owned land in Braunton called La Barre.

## Barum

This is another name for Barnstaple. A document from around 1410 refers – in Latin – to Barnstaple as 'de Barum alias Barnastopolie'. Barum is probably a shortened version of one of the Latin forms of Barnstaple (ad Barnastopolitum) used in early documents. Although it was occasionally used over the centuries, the Victorians revived the use of Barum as a popular alternative to Barnstaple.

## Beaple, Grace

Grace Beaple was the widow of the wealthy Barnstaple merchant Richard Beaple. For a few weeks in the summer of 1645 she was hostess to the Prince of Wales, later Charles II, when he stayed at Barnstaple during the Civil War. Her house is known to have been at the southern end of High Street and tradition suggests it was on the site of No. 103 High Street and included a decorative plaster ceiling in a room later known as the Prince Charles Room, which was destroyed during alterations to the property. Although her husband had been a Parliamentary supporter, his widow's opinion is unknown, but it is said she prepared the prince's food herself and lent him money. She died before the Restoration, but her representatives received £200 from the king in respect of his time here.

## Beaple, Richard

Grace Beaple was the third wife of Richard Beaple, a prominent Barnstaple merchant and mayor of Barnstaple. He had family connections with several of the other prominent Barnstaple families and was mayor three times. His two sisters married into the Delbridge and Horwood families and his first wife was Mary Peard, daughter of Richard Peard of Barnstaple. His second wife was Catherine Cade, whose father was also a Barnstaple merchant, and his third wife was Grace, who had been born a member of the Gay family. His daughter Elizabeth Beaple married Anthony Gay of Goldsworthy in Parkham parish, who was probably related to Grace. Elizabeth and Anthony's son was the grandfather of John Gay of The Beggar's Opera fame. Richard Beaple's second daughter, Anne, married John Penrose, who left money for the erection of the almshouses in Litchdon Street. Richard Beaple was one of the executors of Penrose's will responsible for the almshouses, which feature on his monument in the Parish Church. He was born in 1564 and died in 1643.

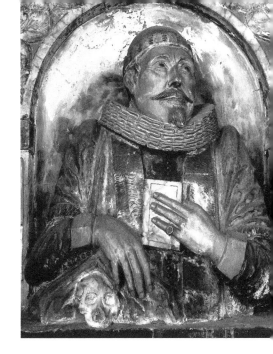

The memorial to Richard Beaple in St Peter's Parish Church.

## Bear/Barre Street

Bear Street is one of several streets in Barnstaple that the meaning of which is disputed. It was recorded as Barrestret in 1394 and Barestret 1550. The name is believed to refer to a bar or barrier at the entrance to the town, but it is possible it is named from the De La Barre family.

Bear Street, first recorded as 'Barrestret' in 1394.

# Bencraft, Lionel

Lionel Bencraft was a prominent solicitor in Barnstaple for many years. It is impossible to read about legal affairs of this period without coming across his name. He was also town clerk for forty years and followed this by becoming mayor in 1884. His portrait hangs in the Main Chamber of Barnstaple Guildhall, a building he spent his life working in.

# Blake, Martin

Martin Blake was born in 1593 and married Elizabeth, daughter of John Delbridge, but he did not have an easy life. Mainly due to the insistence of his father-in-law, he was appointed vicar of Barnstaple in 1628. He was one of many ministers ejected from their posts during the religious upheavals of the Commonwealth period, although in his case it seems to have been because of his supposed Royalist sympathies rather than his religious practices. At one point it is said a party of horse broke into his vicarage and took him as a prisoner to Exeter. Although he was allowed to return to his family, he did not return to his vicarage until the Restoration in 1660. This was the vicarage in Vicarage Street, which he had rebuilt at his own expense. It still stands today but was altered in 1865 when the road was widened. There is a monument in the Parish Church to his nine-year-old son, Nicholas Blake, which mentions the deaths of four other children in infancy. Martin Blake died in 1673.

# Boutport Street

This is a straightforward name. It is the street that went around the early walls of Barnstaple – 'about the port'. In early centuries, 'port' referred to a market town and was not necessarily related to waterborne trade.

Boutport Street, one of the oldest surviving streets still following the same route.

## Brannam's Pottery

Barnstaple had been a major producer of pottery for several centuries. In 1837, Rendle & Son owned the potteries in Litchdon Street and North Walk. Thomas Brannam joined the firm, later taking over the business. The pottery they produced at this time was fairly basic and utilitarian, such as flowerpots and roof tiles. It was only when Thomas Brannam's son Charles took over the business that the company started to produce the more decorative items it became famous for. In 1886, the new pottery building in Litchdon Street was built that can still be seen today.

At the Great Exhibition of 1851 Brannam won a bronze medal for some sgraffito ware, with Prince Albert himself complimenting the potter on the skill of the piece. The new pieces Brannams produced were considered daringly original and rapidly gained an enviable reputation. Queen Victoria later ordered some pieces from the pottery. The cheque received by the firm, signed by the sovereign, was never cashed and hung in a frame on the wall for many years.

## Brannoc, St

Saint Brannoc (or possibly Brynach) was a sixth-century Welsh saint. He is traditionally associated with Pembrokeshire, where several churches are dedicated to him.

The ancient church dedicated to St Brannoc in Braunton.

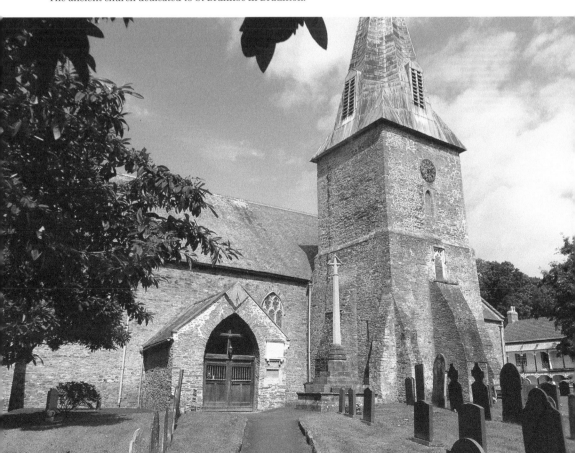

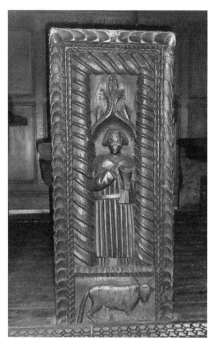

St Brannoc carved in a pew end in St Brannoc's Church, Braunton.

A twelfth-century text says that sometime in the early sixth century, Brannoc travelled to Rome and Brittany, and then on to Milford Haven. During this time, he built several small chapels near the rivers in Wales.

Saint Brannoc appears to have migrated from southern Wales into Devon, and to have founded a monastery at Braunton, where he is supposed to be buried.

# Bridge Chambers

In the 1870s the Bridge Trust embarked on a major project, the results of which can still be seen. Bridge Chambers, on the riverfront side of The Strand, was built between 1872 and 1873. The Ship Inn and some old dilapidated cottages were demolished, as were cottages on both ends of the bridge, as part of the plan was to widen and improve access to the bridge. Upwards of 20 feet were added to the foot and roadways at the corner of the approach to the bridge.

In 1871, *North Devon Journal* reported on the plans for the new building, designed by R. D. Gould. The ground floor was to consist of four sets of chambers, four bonded stores on the quay side and muniment room. The first floor would include a large hall (known as the Bridge Hall) and four sets of chambers, each with a fireproof strongroom, lavatory and other conveniences. There were to be two public staircases and one private staircase for approaching the hall. Messrs Hunt and Sercombe of Exeter had been contracted to carry out the work and the cost was estimated at about £3,500. In 1875, the Bridge Trust paid the town council £1,000 for that part of the house (previously Mrs Carter's) on the other side of the bridge, which was left following the widening of the road. Mr R. D. Gould was again employed to design a house (or chambers) fronting the river and a smaller house with shop for this

site. They were called Bridge End and remained until demolished by the Ministry of Transport in the early 1960s when the bridge was widened. Mr Pitts Tucker's (Mrs Carter's son-in-law) offices had been in part of her house and he was one of the first to occupy the new offices in Bridge Chambers. Another set of chambers was occupied by the solicitors Chanter & Finch (later Chanter, Burrington & Foster and then Chanter Ferguson).

The Large Bridge Hall on the first floor was used by the county court, but was also available for concerts, lectures and other events. The first public concert was held in February 1876 in aid of the Old Church Restoration Fund. In 1877, the Literary and Scientific Institution held a lecture on science and art in their application to furniture, dress and work there and many other educational lectures were given in the hall. In the twentieth century, auction sales frequently took place in the hall.

## Bridge Trust

The Bridge Trust, which still owns Bridge Chambers as well as Bridge Buildings and other properties, is now a charitable organisation and owns several buildings in the town. The Bridge Trust's original purpose was to maintain Barnstaple's bridge. In earlier years they were known as the Keepers or Wardens of the Long Bridge. The exact date of the bridge is unknown, but it is likely from the thirteenth century. It was not until 1961 that the Ministry of Transport took over responsibility for it. The first recorded donation was in 1303 when Alicia de Ackelane made a grant of a yearly rent of 3*d* to the 'Long Bridge of Barnstaple for ever out of a certain tenement for her Soul and the Souls

Once the railway line to Ilfracombe, now a pleasant walk.

of all her benefactors'. Income for the bridge came from other rents and properties over the centuries. There was also a collecting box on the bridge and occasional collections in the town and surrounding parishes as far away as Torrington and Clovelly.

## Burhwitan

The burhwitan was the governing body of an Anglo-Saxon town. In 1018, the Bishop of Exeter announced to the burhwitans of Exeter, Totnes, Lydford and Barnstaple that he had mortgaged one of his estates to a local thegn. These were also the four boroughs recorded in Domesday Book in 1086, but were clearly well established in 1018.

## Butcher's Row

First recommended in 1811, in 1855 a major town improvement scheme took place with the building of the Pannier Market and Butcher's Row. Both designed by R. D. Gould, Butcher's Row comprised of thirty-three shops each with a frontage of 10 feet 10 inches, and pilasters of Bath stone and wrought-iron brackets supporting the roof overhang, with arches over the pavement at each end. It was exclusively a meat market until the Second World War, when the restrictions caused by rationing prompted the council to allow some vegetable and fish shops to be based there. The arches at either end were removed in the 1960s due to continued damage by lorries. Prior to the construction of Butcher's Row, Joy Street was the only road cutting through from High Street and Boutport Street.

Butcher's Row, Barnstaple. Built in 1855.

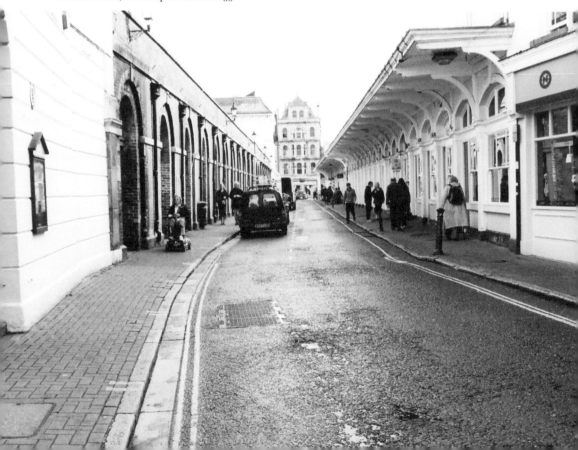

# C

## Castle

The Castle Mound, rising to a height of over 60 feet, is an impressive reminder of Barnstaple's long history. When a castle first appeared in Barnstaple is unknown, but it was probably in the reign of William the Conqueror. The first documentary evidence comes from the early twelfth century when Juhel de Totnes became the first Norman lord to live in the town. He may have replaced an earlier timber castle in stone. It was a motte-and-bailey castle, the motte being the mound and the bailey the associated area around it, which included the area now known as Castle Green and may have extended as far as Holland Street over the area now occupied by the Cattle Market car park. There was no road by the river and the bailey ended in a rampart and ditch or moat, which probably joined the rivers Yeo and Taw.

The castle defences were reduced in height in 1228 on the orders of Henry III, and by the end of that century it was in disrepair. By 1500 it was in ruins. Excavations in 1927 revealed there had been a circular tower (or donjon) on top of the motte with an outer defensive wall. Medieval documents refer to a domestic hall, chamber and kitchen, which were probably within the tower, and a chapel, which may have been in the bailey. There is little evidence of military activity around Barnstaple Castle, but around 1140 Henry de Tracey rode out from here when he was ordered by King Stephen to subdue William de Mohun, who was said to be raiding 'fiercely and turbulently' from his castle at Dunster. He was successful, capturing 104 of de Mohun's knights during one encounter.

## Castle House

In the early eighteenth century, the lessee of Castle Green, Mr Hiern, built a house there. From 1897 one of his descendants, William F. Hiern lived in the Victorian house that had replaced the earlier buildings in 1882. He was a famous botanist who catalogued the botanical sections of the British Museum Library and had large greenhouses erected against the walls of the house. He was the home's last private occupant. Barnstaple Borough Council bought it in 1927, using Castle House as council offices until its demolition in 1976.

Castle House in 1960.

## Chanters Green

There were no parks or pleasure grounds in Barnstaple until 1860 when Mayor John Chanter had the idea of turning an unsightly riverbank area into an attractive scenic park to be enjoyed by the residents of the town. The area in mind was a field covering around 2 acres known as Gooseleigh Marsh and owned by the council. The first stage was completed three years later and was known as Chanters Green. In 1865, its area was extended with land given to the town by William Rock, eventually becoming Rock Park.

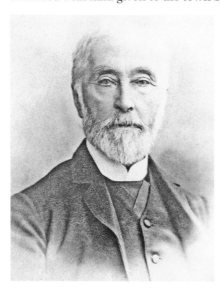

John R. Chanter, mayor in 1860.

# Chapman, Robert

When Robert Chapman died in June 1902 at the age of almost 100, the *North Devon Journal* devoted several columns to his life. Although not a native of the town, he had lived and preached in Barnstaple since 1831. He founded the Grosvenor Street chapel, which remained in Grosvenor Street until moving to its present premises at the former Victoria Street railway station in Eastern Avenue in 1994.

Robert Chapman trained for the legal profession, but when living in London he felt called to religious work and came to Barnstaple, where he had relations, to take charge of the Ebenezer Chapel in Vicarage Street. After several years he established a new chapel in Grosvenor Street in 1848. Schoolrooms were added in 1856 and a day school subsequently established. In 1886, additional premises were built in Richmond Street. He was a very humble man, but he became greatly admired and respected for his devotion to religious study and preaching. He lived in a modest house in New Buildings and followed a simple lifestyle, going to bed at 9 p.m. and rising at 4 a.m. He spent many hours in study and prayer, as well as preaching and caring for his congregation. He walked long distances and frequently went to Ilfracombe before breakfast, returning to Barnstaple for a meeting at 11 a.m. He was highly intelligent and could speak French, Spanish, Portuguese and Italian, and also studied Greek and Hebrew. He had learnt Spanish in order to carry out missionary work in Spain and visited nearly every part of that country on foot – frequently in danger, as preaching the Protestant religion was illegal at that time in Catholic Spain. He did not want anyone to write his biography and destroyed most of his sermons and writings, but his wishes were ignored. He is still remembered by communities around the world, although has been largely forgotten in Barnstaple.

# Chichester Family

The Chichester family are a long-established gentry family with several branches in North Devon, the nearest to Barnstaple being at Raleigh. The site where their mansion stood is now occupied by the North Devon District Hospital. There is mention of a Hugh de Ralegh in 1166. The Ralegh family survived until 1377 when John Raleigh died and his heiress, Thomasia, married Sir John Chichester and so brought the Ralegh estates over to the Chichester family. Arlington also passed to the Chichesters at that time and a separate branch of the family was established there in 1535 with a grant to Amyas Chichester. Youlston was acquired by marriage in 1490 and became the seat of the senior branch of the family when John Chichester moved there from Raleigh (which was later sold to Arthur Champneys, a Barnstaple merchant) between 1655 and 1666. Another estate was acquired when Thomasine de Hall married Richard Chichester and so the Hall estate (near Bishop's Tawton) passed to the family. John Delbridge's son Richard married Elizabeth, a daughter of John Chichester. She died young in childbirth and there is a memorial to her in Barnstaple Parish Church. In the early seventeenth century the Chichesters also acquired the Pill estate between Bishop's Tawton and Barnstaple, which became a secondary house of the Chichester of Hall family.

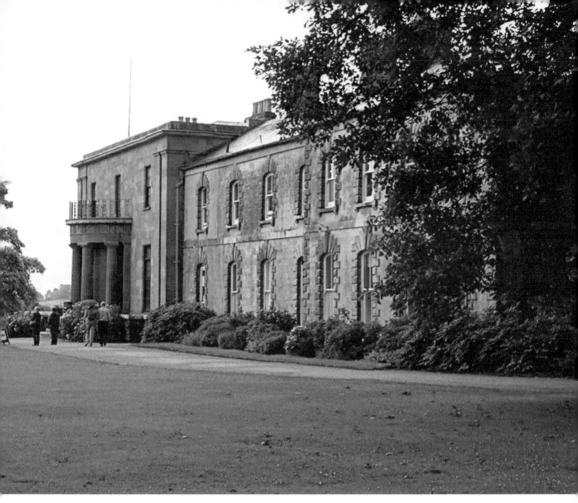

Arlington Court, just outside Barnstaple. It is owned by the Chichester family.

In 1566, John Chichester of Raleigh, who had recently purchased the Castle Manor, sold most of his interests in it to the mayor, Corporation and aldermen of Barnstaple. Importantly, this gave the town control of the riverbank, Strand and quayside. Subsequently undeveloped areas were rented out for houses, shops or stores.

## Chichester, Sir Francis

Francis Chichester was born in the rectory at Shirwell, near Barnstaple, in 1901. At the age of eighteen he emigrated to New Zealand, where in ten years he built up a prosperous business in forestry, mining and property development. He returned to England in 1929, qualifying as a pilot, before joining the Royal Air Force Volunteer Reserve during the war.

On 27 August 1966, Chichester sailed his ketch *Gipsy Moth IV* from Plymouth and returned there on 28 May 1967, after 226 days of sailing, having circumnavigated the globe with one stop in Sydney, thus becoming the first person to achieve a true circumnavigation of the world solo from West to East.

Eleven months later, Chichester was knighted by the Queen, who used the sword Elizabeth I had used to knight Sir Francis Drake.

Elizabeth,
56 Broadfield Road,
BARNSTAPLE.

The special edition postage stamp celebrating Sir Francis Chichester, 1967.

# Chivenor

In 1934, Chivenor Farm was sold to be used as a civil airfield. Known as Barnstaple and North Devon Aerodrome, the site was taken over by the Royal Air Force in May 1940 for use as a coastal command station, becoming known as RAF Chivenor. After the Second World War, the station was largely used for training. There were two units based there initially: No. 3 Coastal Operational Training Unit and No. 252 Squadron.

From 1942 onwards, the role of Chivenor was changed to anti-submarine patrolling. In 1974 the station was left on 'care and maintenance', with the RAF returning in 1979. Finally, in 1994 the airfield was handed over to the Royal Marines.

Chivenor in 1934, when still a civil airfield.

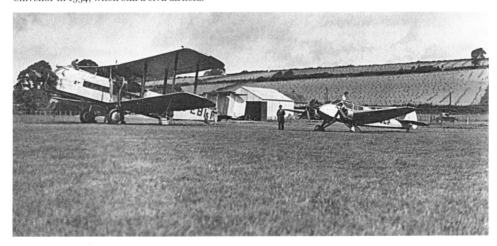

# Cholera

In August 1849 the dreaded disease cholera appeared in Barnstaple. The first victim was William Saunders, a tanner, who died only twelve hours after first becoming ill. On 23 August two more deaths were reported. The town authorities immediately began 'precautionary measures, personal and domestic', with members of the town council dividing themselves into committees and making house-to-house inspections. The mayor requested that all local residents take any pigs that they were in possession of and remove them outside the town.

On 11 October the *North Devon Journal* reported that cholera had broken out in the workhouse, with seven people dying there. By November it was all over. Out of seventy-two cases, twenty-four had died. Cholera did not make a reappearance in the town.

# Civil War

The majority of Barnstaple's population were Nonconformist in their religious views and Parliamentarian in their political outlook. When war between king and Parliament became inevitable, Barnstaple's leading men took measures to defend the town. By January 1643 trenches had been dug and a fort built at Fort Hill. A military rate helped to pay for the defences and a Council of War met regularly at the Guildhall. As Barnstaple was an important port with many wealthy merchants, there was no chance the opposing armies would ignore the town. In September 1643 the town surrendered to the Royalists following the surrender of Bideford and Appledore. Although it had been agreed the town would be free from a garrison, it was occupied in February 1644 after continuing to cause trouble for the Royalists, encouraged by George Peard, the local MP.

In June 1644 the Royalists withdrew a substantial number of troops to help the queen, Henrietta Maria, escape from Exeter. The local Parliamentary supporters seized the chance to regain control of the town and repelled a Royalist force sent to quell their uprising. A Parliamentary force arrived to assist them, but once more the fortunes of war favoured the Royalists and the town was besieged by Lord Goring's troops. Barnstaple surrendered in September and was occupied by the Royalists in December 1644, when Sir Allen Apsley became governor of the town. He strengthened the defences and in June 1645 Barnstaple was considered safe for the Prince of Wales (later Charles II) and his entourage to stay for a few weeks. He stayed at the home of a wealthy widow named Grace Beaple. In the following months it became clear the Royalists were losing the war and, following their defeat at Torrington in February 1646, Barnstaple was besieged by Parliamentary forces. In April 1646 Sir Allen Apsley agreed to surrender the town. For Barnstaple the war was over.

# Codden Hill

But the hill of all hills, the most pleasing to me,
Is famed Codden, the pride of North Devon;
When its summit I climb, O, I then seem to be
Just as if I approached nearer heaven!
When with troubles depress'd to this hill I repair,

> My spirits then instantly rally;
> It was near this bless'd spot I first drew vital air,
> So – a hill I prefer to a valley.

So wrote John Gay. Codden Hill is the highest hill around Barnstaple and can be seen rising to the south beyond Newport and above Bishop's Tawton. Swaling, or setting fires to burn off the undergrowth, used to be allowed in March every year and provided an opportunity for family outings. A newspaper report of 29 January 1917 reported a blaze practically from end to end of the hill – nearly a mile – which may have been caused by swaling. It could be seen from miles around and scores of people walked from Barnstaple to Bishop's Tawton to view the sight of the burning hill, 'the sight being a splendid one' as the *Western Times* described it. Oddly, it does not seem to have been regarded as dangerous.

## Coney Gut

Coney (or Cooney) Gut, sometimes called Coney stream or river, is the stream that formed the boundary between Barnstaple and Newport for centuries and made it impossible to travel directly between the two. By the seventeenth century there was a causeway and bridge, although it was still marshy and further work to drain the area and culvert the stream took place before the creation of Rock Park.

## Congregational Churches

The first independent congregation meetings were held at Castle Street, but a group split away to build a chapel in Cross Street in the early eighteenth century. In 1753, the two congregations united and worshipped at Cross Street until the 1970s when the Congregational Church became part of the United Reformed Church. Their final building of 1870, designed by R. D. Gould and his son, still stands in Cross Street and is now an antiques centre. The congregational schoolrooms were built on the corner of Cross Street and Castle Street in 1854, although the present building, much altered on the ground floor, is the later building of 1894.

Ornate entrance of the Congregational Church, Cross Street.

# Corn Exchange

Designed by R. D. Gould in 1855, the Music Hall (later the Albert Hall, and now, The Queen's Theatre) opened in the November of that year as a dual-purpose building. The ground floor was for use as the new Corn Market and the upper floor was the Music Hall. Later, in 1864, the Pannier Market, which already extended under the Guildhall, was continued into the Corn Market.

Large quantities of food were stored there during the Second World War. Late one night in November 1941, after a dance in the upper Music Hall, a fire started. Rapidly taking hold, by the following morning the building was just a shell. It was rebuilt in 1952 and renamed the Queen's Hall.

# Corruption in Politics

Richard Bremridge and fellow politician Sir William Fraser stood for election as Barnstaple MP in the infamous 1852 election (the town at that point still returned two Members of Parliament). They had originally won the election but were unseated after an inquiry. The electoral commissioners found that, of the 696 voters who polled, 255 received bribes for their votes. One voter, summing up local opinion, stated, 'I don't care who I vote for – hog, dog or devil.' The case was heard in the Guildhall and was widely reported throughout the country. W. F. Gardiner, editor of the *North Devon Journal*, is quoted as saying: 'One cannot deal with the political history of Barnstaple with anything approaching pleasure.' A few years later, Bremridge again stood for election, this time winning on a fair vote. His grand and very large portrait now hangs proudly in the Guildhall, looking down on the place where he once stood trial.

Richard Brembridge MP.

## Cross/Crock Street

Recorded as Crockestrete in 1482 and Cross Street alias Crock Street in 1670, this important street leading from the quay to the High Street was originally named after the 'crocks' of the potters' market, which used to be held there. Gradually, the name changed after the potters were banished from the street because they were obstructing the roadway.

## Cyprus Island (also known as Monkey Island)

This ornamental island in a lake was created in 1879 following the extension of the railway to Ilfracombe in 1874, when an embankment of the river between Pottington and Castle Quay cut off the view of the river from North Walk. An embankment by the side of the Yeo provided a large triangular tract of land. It was yet another project overseen by the borough surveyor, R. D. Gould, who wrote to the *North Devon Journal* in May 1879 giving details of those who had contributed to the wildlife. A male swan had been given by Captain Williams of Pilton House, with a female swan being provided by Mrs Hiern of Castle House. Mr Pedler, confectioner of Vicarage Street, had given a couple of Aylesbury ducks, with another duck being supplied by Mrs Harris of Roborough, Pilton. Dr Forester and other gentlemen gave dark Muscovy ducks. Brown Muscovy ducks were the gift of Mr Turner of Abbotsham. Seeds of various kinds for planting the island and banks were donated by Messrs Pratt and Hutchings.

A flagstaff and Union flag were placed at one end of the island, but the flag had to be replaced when it was 'stolen by some miscreants one night'. The new additions to the landscape were considered a great success, with the reporter in the *North Devon Journal* remarking, 'A more charming scene could hardly be imagined, especially in contrast with the hideous waste covered with sand, mud or water which it has superseded.' The reporter considered that Mr Gould 'never did anything so much to surprise and delight his fellow townsfolk'.

Interestingly, the newspaper also mentioned that the Castle House had been much enlarged, 'and is now a handsome edifice more worthy of its fine situation'.

Although they could not have known it in 1879, Cyprus Island would last less than twenty years. It vanished when the new railway line to Lynton was constructed and passed over what had been the centre of the ornamental water. Although the new railway was not opened until 1898, the island disappeared in February 1896 when the local newspaper reported that the water in the pond was allowed to flow into the river before the trees and shrubs on the island were removed. This was done on a Saturday and on the Monday 'a couple of hundred persons became engaged in the exciting sport of "forking" and otherwise catching the eels, flat fish and mullet which had flourished in the Pond'.

## Delbridge, John

John Delbridge was born in 1564 and died in 1639. His lifetime coincided with the peak of Barnstaple's prosperity and he was one of several prominent merchants to take advantage of the opportunities. He took a leading part in the town's affairs, being both mayor and MP at various times. By 1591 he was exporting the cheap worsted cloth called Barnstaple baise and was involved in the Newfoundland fishing trade. He was also involved in sending emigrants to the new colonies in Virginia. In 1620 his ship, *The Swan*, sailed with seventy new settlers; unusually for those times none died on the voyage, partly due to the care Delbridge took in provisioning the ships. He also sent many ships to Bermuda and profited from the new crop of tobacco grown there. In addition to his commercial activities, Delbridge supplied information gained from his voyages to Robert Cecil, Elizabeth I's chief minister. He took his responsibilities seriously and spoke up for the town in Parliament. When bad weather caused a grain shortage he was involved in obtaining supplies to ensure the poor did not starve. His name is on the Tome Stone in front of Queen Anne's Walk, as he was mayor in the year it was placed on the quay.

## Derby

At the end of Vicarage Street is an area that has been known as Derby since the nineteenth century – from the Derby connections of John Boden, who built the lace factory there in 1825. In 1828, the factory was sold to John Miller. Before the lace factory was built there the area was known as Stoneybridge, Brickfield or Brickyard. Several streets of houses to accommodate the factory workers were soon erected on nearby land including Union Street, Boden's Row (later Corser Street), Princes Row, Reform Street (named after the Reform Act of 1832) and Newington Street. Many of the streets have now vanished, although the factory building survives without its top floor and cupola, which were removed after a fire in 1972.

## Dodderidge, Dorcas

Dorcas Dodderidge was the daughter of Pentecost and married John Lovering. Their son, also called John, a wealthy Barnstaple merchant, married Elizabeth Venner, daughter of William Venner of Hudscot, Chittlehampton. After John's death Elizabeth married Joseph Baller, apothecary of Barnstaple and uncle to John Gay's brother-

The words 'Bibliotheca Doddrigiana' can still be seen on the Dodderidge library.

in-law. John and Elizabeth Lovering were the parents of Dorothy, who married Samuel Rolle, and Susanna, who married Richard Ackland. Both of the sons-in-law became MPs for Barnstaple – probably due to the Lovering family influence. These relationships are typical of the complicated connections of the leading merchant and gentry families at that time.

## Dodderidge, John (son of Pentecost)

The son of Pentecost, another John Dodderidge (1610–66) gave Barnstaple its first free library – 112 volumes, mostly about theology and in Latin. A special room was added to the Parish Church in 1667 to house the books, and although the books are no longer there, the words 'Bibliotheca Doddrigiana' can still be seen on the east wall of the church.

## Dodderidge, Richard and Pentecost

Richard and Pentecost Dodderidge were two other prominent merchants at the same time as John Delbridge. Richard came from South Molton, but was established in Barnstaple by 1582. He was mayor in 1589 and in 1590 became extremely wealthy when his ship, *The Prudence*, returned from a privateering trip with a captured ship taken off the coast of Guinea. Among other items were four chests of gold valued at £16,000. The following year *The Prudence* came home with a prize ship worth £10,000.

His son Pentecost was mayor in 1611, 1627 and 1637 and also MP for the town in 1621, 1624 and 1625. He was frequently in trouble with the authorities, being fined for letting the chimneys and gutters of his house fall into disrepair. Also, in 1636 (when he was at least sixty), he was in trouble for refusing to become captain of the town's trained bands. He was a fervent Parliamentarian and offered to lend £50 towards fortifying Barnstaple against the Royalists. He died in 1644 and left over £100 to charity in his will, including £39 for a weekly bread dole in Barnstaple and £30 to help poor weavers. His three surviving daughters had all married Exeter merchants.

Another son, John, was born in 1555 and died in 1628. He went to Exeter College, Oxford, and became a very successful lawyer, a judge of the King's Bench and solicitor-

general to James I. He was a founder member of the Society of Antiquaries. John Dodderidge retired to Exeter and he and his wife are buried in the cathedral there.

# Domesday Book

In 1086, William I had been king for twenty years and commissioned a detailed survey of his kingdom – the Great Survey – later becoming known as the Domesday Book. Barnstaple has its own entry. The translation of which is as follows: 'The king has a borough called Barnestaple, which King Edward held TRE. There the king had forty burgesses within the borough and nine without, and they pay forty shillings by weight to the king, and twenty shillings in number to the Bishop of Coutances. There also twenty-three houses have been laid in ruins since King William has had England.' Barnstaple was one of several boroughs that he decided to keep in his own hands.

# Dornats

Charles Camille Dornat settled in Barnstaple in the 1850s and by 1868 had established Dornats Mineral Water Factory. He was a wine expert, chemist and apothecary who dispensed medicines stored in soda siphons to local doctors.

Originally based in Holland Street, the factory moved to Tuly Street (on the site now occupied by the library) in 1870 and remained there for over a century. At first the main product was ginger beer, but other mineral waters were added. Although there was a serious fire in 1879, the firm thrived, and by 1897 could produce 1,000 bottles a day. Charles Dornat died in 1883 at the age of fifty-one. His eldest daughter, Annie Hortense, who had married Charles Alfred Youings, inherited the business. The firm finally closed in 1980 when Richard Youings retired.

Advert for Dornat & Co. in the *North Devon Journal*.

# E

## Eadwig

King Eadwig came to the throne at the age of about fifteen in AD 955 and died in AD 959. The first known coin minted in Barnstaple is dated to this short reign.

## Ebberley Lawn

According to Gribble's 1830 *Memorials of Barnstaple*, Ebberley Place was a 'neat and beautifully situated row of houses, eight in number'. He states that it had been formed out of a building previously used as a horse barrack by Henry Hole of Ebberly House (near Torrington), who purchased the property from the government in 1817 and had recently sold it. Further houses were added on the other side in 1868 and it became known as Ebberley Lawn. There has been an Ebberley Arms public house in Bear Street since at least 1837.

## Ebrington

Viscount Ebrington was the title of Earl Fortescue's son. He was MP for Barnstaple in 1804–07. There was an Ebrington Inn at Newport in the nineteenth century. The *Lady*

Early postcard showing Newport High Street.

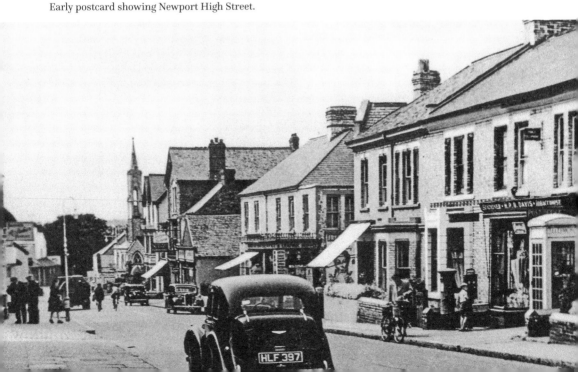

*Ebrington* was a ship built at Barnstaple and launched amid great celebrations in August 1852. It was reported that there were more than 2,000 spectators lining the shore by 7.30 a.m. to watch as she was towed down the river. She sailed to Liverpool and from there took emigrants to Australia.

## Electricity Station

In 1903, the borough of Barnstaple electricity works were completed and officially opened by the mayoress and her daughter. There were only eight public lamps lit by this new form of power to begin with – situated in the High Street, Boutport Street, Joy Street, The Strand and The Square. There were also seventy private houses with more soon following. Although the electricity works closed in 1950, the façade is still visible in Castle Street.

## Elephant Lane

Elephant Lane was an alternative name used for Paiges Lane during part of the nineteenth century. It referred to the Elephant Inn, which was established there before 1837 but had closed before 1878.

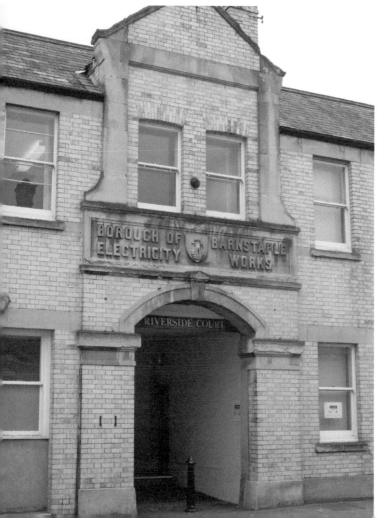

Façade of the Electricity Works, built in 1903.

# F

## Fair

The first written reference to Barnstaple Fair is from a document dated 1154. It states that a grant of 10s made to the monks of the abbey of the Holy Saviour was to be paid at the annual September fair of Barnstaple. Although the exact date and days upon which the fair was held changed over the centuries, in 1852 the Barnstaple Market Act set the date as 'the Wednesday preceding the 20th of September', and that it was to last for four days.

Traditionally, it began with the first day allocated for the cattle and sheep fair, the second day for the horse fair and the final two days for the pleasure fair. Buying and selling goods and animal feed would continue for the entire four days.

The events start with the official opening of the fair ceremony at the Guildhall, which was followed by the proclamation of the fair. The council, led by the town clerk, mace bearers, mayor, councillors and other dignitaries, proceed around to the sites of

The flower arch outside the Guildhall for Barnstaple Fair.

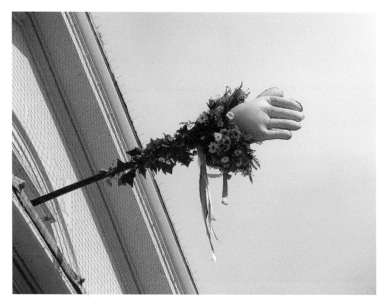

The Fair Glove showing above the Guildhall door on fair day.

the four ancient gates, where the town clerk reads out the ancient fair proclamation. On the morning of the opening ceremony, the large stuffed white glove is bedecked with flowers and projected from a window above the Guildhall entrance gate on a pole.

The ceremony and proclamation still takes place each year, but the fair itself is now just a pleasure fair.

# Floods

Flooding was common in the low-lying areas of the town. The Square was a marshy area often inundated at high tide until it was drained in the eighteenth century. Causeways or raised pavements were required at both ends of the bridge and from the end of High Street across to Litchdon Street. The most remarkable flood was in January 1607 when the town clerk recorded in his journal that the water was 5 to 6 feet higher than anyone living had seen it. One house was destroyed, killing the occupier and his two children. Several other properties were damaged, and goods stored in houses and cellars near the quay were lost.

# Food Riots

Just after 8 p.m. on Friday 8 November 1868, a riot broke out in Barnstaple. It had become evident that evening that a disturbance was imminent. Bands of men and some women marched through Green Lane and Derby beating tin kettles and shouting. All the butcher shops closed amid yelling and cries of 'We want cheap beef and bread,' and 'let us have our rights'. The police soon appeared and the mob rushed off through Boutport Street and Joy Street, where stones where thrown through a baker's window. The police chased the mob who then proceeded through Vicarage Street, where almost all the shop windows were smashed. The mayor, some councillors and magistrates who had assembled at the Guildhall were informed of

the trouble taking place. With help from several shopkeepers, the police caught the ringleader, a Mr Loosemore, who was accused of inciting the mob to take revenge on the shopkeepers for 'cheating us of our due, and growing rich on it'. The crowd eventually dispersed around 2 a.m., but only after much damage had already been done. The news of the riot was reported widely all over the country.

## Fortescue Family of Filleigh

The Fortescues were one of the influential landed families in North Devon. The Royal and Fortescue Hotel in Boutport Street (which was the Fortescue Arms for many years) displays their coat of arms over the entrance. Originally established in South Devon, in 1454 a younger son married the heiress to the Denzil (or Densell) estates and so acquired Filleigh, Wear Gifford and Buckland Filleigh. Weare Giffard was their chief North Devon residence until the seventeenth century, when they moved to Filleigh and Weare Giffard became a secondary home. The estate grew over the centuries, until in 1873 it was one of the four largest estates in Devon. Although the Fortescues of South Devon were Royalists during the Civil War, Hugh Fortescue of Weare Giffard supported Parliament. It seems he managed to maintain an appearance of neutrality, but supported the defence of Barnstaple financially and was appointed to the Council of War in May 1643. William Fortescue, of the Buckland Filleigh branch of the family, attended Barnstaple Grammar School at the same time as John Gay and they remained friends. He became a lawyer and eventually Master of the Rolls. John Gay's sister, Joanna, married William's brother. Earl Fortescue laid the foundation stone of the North Devon Infirmary on 5 January 1825 and on 8 September 1910 his successor formally opened the new grammar school. In Newport there is a Fortescue Road, Clinton Road and Chichester Road, a reminder of the landowners who once dominated the area.

## Funeral, Charles Sweet Willshire

Local Liberal politician Charles Sweet Willshire was known during his lifetime as 'One of the most influential political leaders in the Western Counties'. Willshire was the son of Thomas Lambe Willshire, owner of Newport Iron Foundry. Charles was his only son and had shown an interest in politics from an early age. He was to become the youngest ever town councillor and went on to be the leader of the Liberal Party in North Devon, and mayor for a double term in 1876–77. Willshire was described as 'frank and honest, open as the day, bright as sunshine. As a politician he was a vigorous champion of advanced Liberalism, and served his party with fidelity that never swerved and a courage that nothing seemed to daunt. To his opponents he proved an invincible foe – straight and hard hitter, yet generous withal'.

Willshire was a member of several Friendly Societies and sat as a local magistrate for many years. He had a reputation of being extremely fair and was known to pay the fines of those he considered in need of assistance.

It is remarkable that this local councillor was said to be Prime Minister Gladstone's 'most trusted councillor' due to his honesty, unfailing support of the Liberal Party

and his political skills. He developed ideas in connection with registration and organisation of local elections that were adopted by both the Liberal and Tory parties throughout the country.

When he died at the early age of fifty-two his funeral was – and remains – the biggest Barnstaple had ever seen. A procession started from his house in Taw Vale Parade, consisting of members of the local Liberal Party, members of the Tory Party, the Devonshire Volunteer Force, the entire council, members of the government (the prime minister sent his apologies) and almost every local authority organisation, as well as members of the public. During the ceremony businesses in the town closed their shutters out of respect and in the houses of private individuals, blinds were drawn. It is highly unlikely that the passing of any politician today would cause such genuine grief and regret.

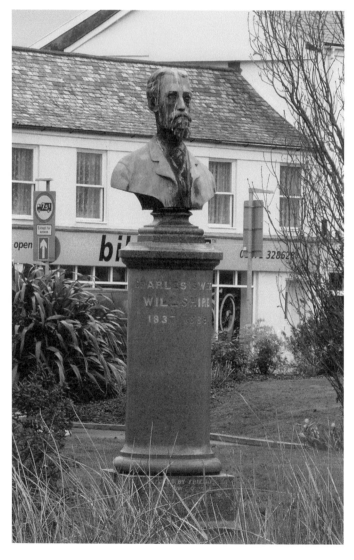

The memorial to Charles Sweet Willshire on The Square.

# G

## Gay, John

John Gay is probably Barnstaple's most famous son. Born in 1685, his father came from an established merchant family and his mother was the daughter of the Nonconformist minister John Hanmer. He went to London where he soon abandoned his apprenticeship with a silk mercer and joined the literary set, becoming friends with Jonathan Swift and Alexander Pope. He had some success with poems and plays, but struggled to make money until the overnight success of *The Beggar's Opera* in 1728. A sequel, *Polly*, was printed but banned from performance on stage. John died in 1732 and was buried in Westminster Abbey. His fortune of around £6,000 was inherited by his sisters, Katherine Baller and Johanna Fortescue.

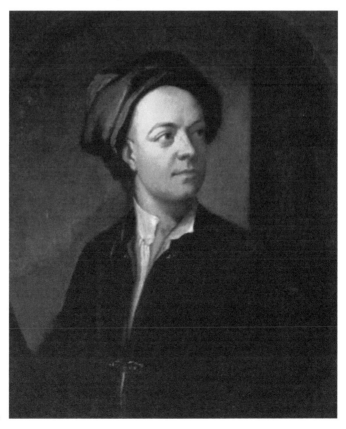

John Gay, poet and playwright.

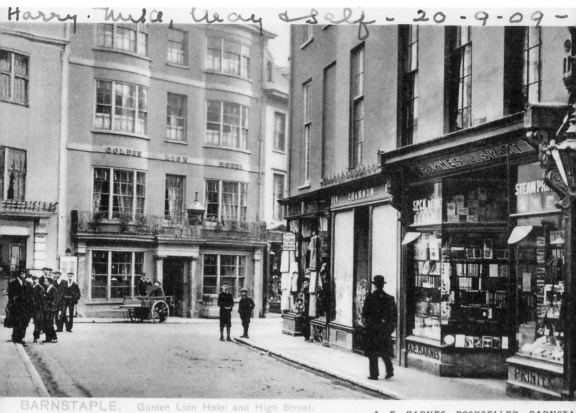

The Golden Lion Hotel, now No. 62 The Bank.

## Golden Lion

The eighteenth-century Golden Lion Tap once provided accommodation and refreshments for the servants of those staying at the Golden Lion, just around the corner at No. 62 Boutport Street. This is now a restaurant and may have been built as the town house of the Earl of Bath in the early seventeenth century, but around 1760 it became the Golden Lion coaching inn. Fortunately, the magnificent plaster ceiling has been preserved from the original house and can still be seen, although the building also accommodated a bank and building society before becoming a restaurant.

## Gould, R. D.

Richard Davie Gould was borough surveyor for fifty years and designed so many of Barnstaple's most prominent buildings that the *North Devon Journal* renamed Barnstaple 'Gould's Town' at one point in his career. As well as Bridge Buildings and Bridge Chambers, he also designed the Pannier Market and Butcher's Row, Taw Vale Parade, the Congregational Jubilee Schoolrooms, the Music Hall (now The Queen's

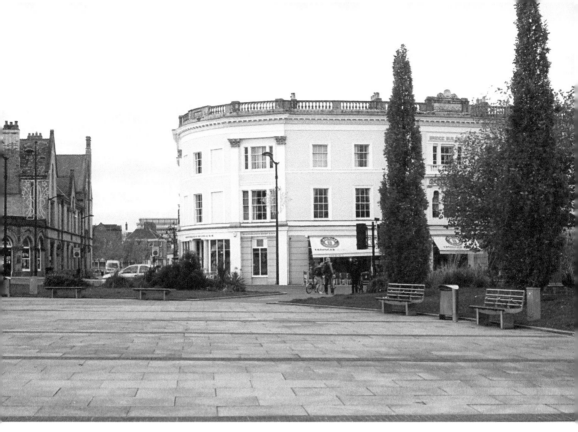

Bridge Buildings and Bridge Chambers, both designed by R. D. Gould.

Theatre), the Bath and Wash House (behind Queen Anne's Walk), the North Devon Infirmary, Ebberley Lawn, the Congregational Church in Cross Street, the layout of Rock Park, Nos 3–6 Castle Street and many more around North Devon.

## Grammar School

In 1550 Barnstaple Corporation purchased St Anne's Chapel, one of the chantry chapels suppressed in 1547, and it became the town's grammar or high school until the opening of the new grammar school in 1910. There is little information about the grammar school before this time, but it was probably in the chapel of St Nicholas at the West Gate. John Gay was educated at the school at St Anne's and his schoolmaster, Robert Luck, later claimed some credit for his pupil's success. In his 1830 *Memorials of Barnstaple*, Gribble stated that the usual number of pupils was around forty and the master was Henry Nicholls, who had been there since 1795 and established a reputation as an able tutor and good disciplinarian. In the later nineteenth century numbers declined and, as Earl Fortescue said at the opening of the new grammar school, the old school, 'became somewhat feeble in old age'. This was partly due to the opening of the Devon County School (later West Buckland School) in 1858.

H. P. Hiern, the last private occupier of Castle House, became chairman of the governors of the new grammar school, which was the first secondary school opened under the auspices of Devon County Council, who had paid half the cost of £14,000. Fees of £2 10s

per term were payable (with a 10 per cent reduction for two or more children from the same family), but there were twelve free scholarships each for boys and girls, decided by examination. Girls and boys were taught separately until the 1960s and the school became part of the new comprehensive system in the 1970s when it was renamed the Park School.

# Guildhalls

There have been three Guildhalls in Barnstaple. The first one, built in the fourteenth century, was situated along The Strand by the Long Bridge. Then, in the mid-sixteenth century, it was decided to build a new larger Guildhall. Built in the classic Tudor style, the new building spanned the entrance to the churchyard, where the iron gates are today. By 1826 this was itself considered too small. Barnstaple-born architect Thomas Lee (who also designed Arlington Court) came up with a design for a new modern building. Erected along the High Street, it contained the main courtroom. The building is owned by the town council today.

Barnstaple's third Guildhall, built in 1826.

# H

## Hankford, Thomasia

A proof of age inquisition was held in Barnstaple on 9 August 1437 to establish the age of Thomasia (or Thomasine) Hankford so she could inherit from her father, mother and younger sister, who had died aged around ten. Her mother was Elizabeth Fitzwarin, who had inherited from her brother Fulk FitzWarin (or FitzWarren). Tawstock was part of that inheritance and it was through Thomasia's marriage to William Bourchier that Tawstock went to the Bourchiers and later the Wreys. Thomasia's father was Richard Hankford, the grandson of William Hankford, who was chief justice of the King's Bench from 1413 until his death in 1423. His monument is in the Annery Chapel of Monkleigh Church.

The proof of age inquisition states that he was present at his great-granddaughter Thomasia's christening and gave her a gilt bowl. Also present was John Mulys of Barnstaple who held a burning torch during the whole of the baptism, which took place at Tawstock church in 1423. John Raymer, aged forty-two, stated that he knew when she was christened because he raised a new hall at Barnstaple and saw very many gentlemen riding to the baptism. Richard Yeo, aged forty, knew because his ship was brought to land at Barnstaple laden with various merchandise. Walter Hayne, aged forty-four, knew because he saw fellow burgesses of Barnstaple give her a tun of wine on the day of her baptism. Thomasia died aged only thirty-one and is buried in Bampton Church, Bampton being another of her manors.

## Hanmer, John and John

Jonathan Hanmer was born in 1606 and married Katherine Strange at Northam in 1637. Their daughter, Katherine, was the mother of John Gay as well as Katherine, Joanna, Jonathan (who died aged around thirty) and a daughter who died aged ten. Jonathan Hanmer was ordained and became vicar of Instow and later Bishop's Tawton, but was one of many Nonconformist ministers ejected from the Church of England following the Act of Uniformity in 1662. Together with Oliver Peard he founded the first Nonconformist congregation in Barnstaple. At first they met in secret, but a meeting house was built near the castle in 1672. His son, John, was also a Nonconformist minister at the Castle Street meeting and later at a second congregation in Cross Street, where a chapel was built in 1705. Jonathan Hanmer died in 1687, two years after the birth of his famous grandson, John Gay. John Gay's parents had both died by the time he was ten and he probably went to live with his uncle Hanmer, who it was said 'took a particular delight in instructing younger persons'. John Hanmer died in 1707, but by then John Gay had entered into his short-lived apprenticeship with a silk mercer in London.

Sydney Harper in his book and stationary shop.

# Harper, Sydney

Harper & Sons were a well-known Barnstaple bookseller and stationer whose shop along the High Street was a feature of the town for many years. Sydney took over the business from his parents: Robert, who died in 1898, and Eliza, who died aged ninety-three in 1915. In 1907, their advertisement stated that they stocked '2,000 6d Novels and all the Latest Out'. In 1910, Sydney Harper wrote a children's history of the town titled *History of Barnstaple for Boys and Girls Past and Present.*

# Hodgson, Frederick

Frederick Hodgson's imposing portrait hangs in the Main Chamber of the Barnstaple Guildhall, where he was MP from 1824–30, 1831–32 and 1837–47. A popular MP whose popularity, it was said, was mainly due to the fact he rarely visited the town or

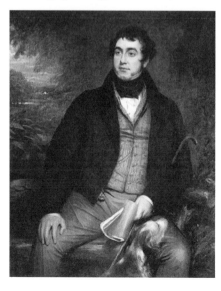

Frederick Hodgson, MP and brewer.

interfered in its political affairs. Hodgson had no connection with Barnstaple at all, but used the town as a 'safe seat' to get him into Westminster.

However, his claim to fame was not to be his political career, but his working one. Hodgson was a brewer and took over the business from his father, George. His brewery at Bow Bridge in London became extremely successful and was instrumental in the creation of Indian Pale Ail (IPA). Hodgson's beer was credited with being the first time a product became known by its maker's name rather than the name of the item produced – Victorian drinkers would ask for a 'pint of Hodgson's' rather than a pint of beer. Both Charles Dickens and William Thackery mention Hodgson's. Unfortunately, Frederick Hodgson died in 1854 without issue, and the company was soon taken over.

## Holy Trinity Church

Holy Trinity Church was consecrated in 1845 at the instigation of Revd J. J. Storr. Most of the cost (stated in one report to have been more than £10,000), including the school and its endowment, was met by the vicar from his own private means. Unfortunately, the construction was inadequate and by 1853 it was necessary to call attention to its 'dilapidated and dangerous state'. After many years funds were raised and the church was rebuilt – apart from the tower. It was rededicated by the Bishop of Exeter in January 1870, when the incumbent was Revd C. Haggard. The event was reported at length in the *North Devon Journal*, which gave details of the old and new architecture, stating that the all the old materials had been used in the new building. The new benches were made out of the old pews, windows had been retained, and the original pulpit, lectern and font were included in the new building.

## Horwood, Almshouses and School

Along Church Lane, once known as Alms Lane, is the Old School Café, originally the building where Alice Horwood established a free school for twenty poor girls in 1659. The girls would have received a fairly basic education, consisting mainly of learning

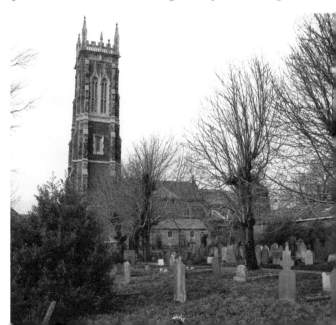

Holy Trinity Church, Barnstaple.

Horwood Almshouses, Church Lane.

to knit and sew (one task they were expected to do was sew the uniforms for the boys at Bluecoats School, nearby). They were also taught to read, but not taught to write as this was considered unnecessary for girls who would only ever need to read their master's or husband's written instructions, but have no need to ever reply.

Next to this are a group of almshouses, part of which were begun by Alice Horwood's husband and completed by her after his death. They consist of eight dwellings of two rooms each to be occupied by sixteen 'poor people', with a small garden plot allotted to each dwelling. Thomas Harrison and Gilbert and Elizabeth Paige were responsible for the remainder of these almshouses, a reminder that before the welfare state the wealthier members of the local community were expected to provide for the less fortunate.

## Hospitals, NDI replaced by NDDH

The North Devon Infirmary was built by public subscription following a meeting in 1824 where £1,059 was raised and many annual subscriptions promised. The site was acquired in 1825, with the first stone laid by Earl Fortescue, also the principal contributor. The twenty-bed hospital opened to its first patients in August 1826. Two years later a wing was added for 'offensive or infectious patients', and further wings were added in 1862 and 1883. It closed in 1978 upon completion of the new North Devon District Hospital, or 'Pilton Hilton' as it was known locally. The buildings were demolished and the Barum Court flats built on the site.

## Huguenots

The Huguenots were Protestant refugees fleeing religious persecution in France. There were earlier refugees, but it was following the revocation of the Edict of Nantes in 1685 that most of the French refugees arrived. Twelve of them arrived in Barnstaple on a December morning that year and were welcomed by the inhabitants. They were allowed to use St Anne's Chapel, then the grammar school, as a place of worship on Sundays for many years. One of the most successful of the Huguenot families in Barnstaple was the Servant (or Servante) family, who were goldsmiths. A Servant was mayor in 1793 and 1802. Matthew Roch, from another Huguenot family, was mayor in 1741 and 1753, and his son, Mounier Roch, in 1760 and 1778. Mounier Roch was one of the founders of the first Barnstaple Bank in 1791.

# I

## Imperial Hotel

The Imperial Hotel was founded by Annie Hortense Youings (born a Dornat) and her husband, who bought Litchdon House in The Square in 1898 and opened it as the Imperial Private Hotel. This was the year the railway to Lynton opened and the local paper noted, 'The general view is that the opening of the Lynton and Barnstaple Railway has led many more visitors to North Devon to make Barnstaple their headquarters than hitherto.' By 1901 the hotel was expanding into neighbouring properties, with twenty-seven additional bedrooms being provided as well as a large dining hall, billiard room, library and seven or eight sitting rooms. It was noted that there were several Americans staying there. Mr and Mrs Youings retired in 1929 and the hotel was taken over by Trust Houses Ltd. The local paper thought the establishment of the Imperial 'had done more than anything else to secure recognition of the claims of Barnstaple as a holiday centre'.

The Imperial Hotel, once a private house.

# Incledon, Benjamin

Benjamin Incledon was a barrister and Recorder of Barnstaple from 1758 until 1796 and took a great interest in the municipal records, compiling a list of the mayors of Barnstaple. He inherited wealth and spent much time investigating the history of the ancient families of Devon and compiling pedigrees. Born in 1730, Benjamin Incledon was the son of Robert Incledon, a member of the ancient Incledon family of Braunton. Robert built Pilton House in 1746 and Benjamin Incledon's son, Robert Newton Incledon, who was also Recorder of Barnstaple, sold it in 1806 and built a new mansion at Yeotown, Goodleigh. Benjamin Incledon's portrait hangs in the Guildhall.

# Instow

'Instow, a much improved village and bathing place, pleasantly situated on the shore of the broad estuary of the river Taw and Torridge, opposite Appledore...' This description comes from White's 1850 Directory of Devon, by which time the old village of Instow, with its church on the hill overlooking the estuary, was becoming a fashionable watering place. It was popular in winter as the *Exeter and Plymouth Gazette* reported in February 1849: 'The mildness of the air and healthfulness of the climate render Instow a desirable place for invalids during the inclemencies of winter.' A quay had been built in the 1620s and there was probably a pottery there in the seventeenth century. There were certainly potters there in the eighteenth century. In 1798, William Fishley, potter of Instow, with George Fishley (possibly his nephew who later moved to Fremington) registered the *Sparrow,* a 12-ton sloop, 'solely employed in carrying Earthen Ware coastwise'. Revd John Downe was vicar of Instow for thirty years in the early seventeenth century, dying in 1631. He was the grandson of Henry Downe, merchant of Barnstaple, and his wife, Cecily Jewel, was sister of John Jewel, who later became Bishop of Salisbury. In the nineteenth century the old pottery sites near the water disappeared and often became guesthouses. A sailing club was formed in 1905 and the author Henry Williamson became a member in the 1930s. By 1944, when large numbers of servicemen, including many Americans, were stationed at Instow and other coastal resorts of North Devon, the clubhouse became a popular social centre. After the war it became the North Devon Yacht Club.

# J

## *Jeremiah*

The *Jeremiah* was a Barnstaple ship that carried earthenware direct to Jamaica for John Christmas in 1695. It is known that North Devon pottery was reaching Jamaica before that date, although it is not certain by what route because fragments have been discovered by archaeologists investigating the site of Port Royal, which was destroyed by an earthquake in 1692. In 1683, sugar, lemons and molasses were imported from Jamaica by the *Fyall Merchant.*

## Jewell, Harriette Ellen

Harriette Ellen Shaddick married Frederick Ashton Jewell at Newport Parish Church in 1891. They were mayor and mayoress of Barnstaple from 1912 until 1918 – throughout the First World War. Mrs Jewell was very active in numerous charitable activities during this time, including raising funds and ensuring the many Belgian refugees who arrived in Barnstaple were welcomed and provided for. In March 1917 she was presented with the decoration of the Russian imperial crest in recognition of her services in connection with Russian Flag Day. Money raised in the Barnstaple Russian Flag Days went towards a Barnstaple bed in the Anglo-Russian hospital at Petrograd.

Harriette Jewell, wife of Frederick Jewell, mayor throughout the First World War.

In 1919, at the celebrations to commemorate the ending of the war, she planted a tree in Rock Park and there were fireworks outside their home in Trafalgar Lawn. In 1920, she became the first lady councillor on the town council. In her obituary in the *North Devon Journal* it was said that in Mrs Jewell 'the poor in particular found an ever generous friend'. Her husband died, aged fifty-four, in 1921 and her eldest son at the age of thirty-five in 1927. Following Mrs Jewell's unexpected death at the age of sixty-five, when visiting her daughter and son-in-law in Bath, flags were flown at half-mast over Barnstaple Guildhall and the Conservative Club. The funeral service was held at Holy Trinity Church and the interment at Bishop's Tawton parish churchyard, where her husband was buried. There were many mourners, including the mayor and several councillors, as well as over 100 floral tributes.

## Jewell, John

John Jewell from Berrynarbor was educated at Barnstaple Grammar School. He became a Protestant exile during the reign of Mary l, but returned in 1559 when Elizabeth was queen. He became Bishop of Salisbury and played a leading part in the establishment of the Church of England, writing the *Apologia pro Ecclesia Anglicana* (Apology or Justification for the Church of England) published in 1562, which was placed in every parish church in England. He died in 1571, when John Delbridge was seven years old. His niece, Agnes Downe, would become John Delbridge's wife.

## John Gay Theatre

In January 1938 the John Gay Theatre opened in part of the former cabinet works in Newport, sometimes known as Oliver's Cabinet Works. Leading sponsors of the new

John Gay Theatre, which opened in 1938.

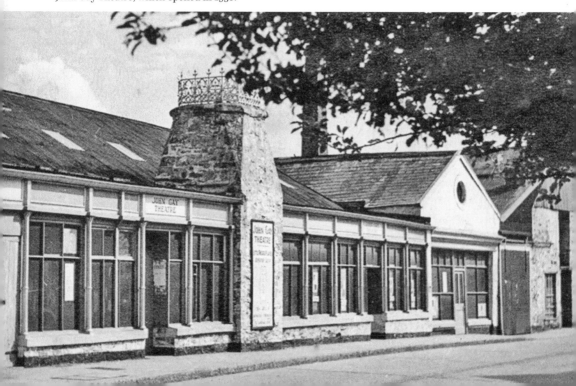

theatre were the town clerk, Mr J. H. L. Brewer (president of the Amateur Operatic Society) and Mr Bruce Oliver (conductor of the Barnstaple Orchestral Society). It was a repertory theatre with a professional company based there for a few years before they moved to the former Foresters' Hall in 1950. In June 1938 the first production in Barnstaple of John Gay's *The Beggar's Opera* was performed at the theatre by the Barnstaple Amateur Operatic Society.

## Joy Street

The origin of this street name is obscure. There was a Joycross in 1460, but the street was referred to as Eastgate Street until the mid-sixteenth century. It has been suggested that it is named after the Joy (or Joye) family who lived in Barnstaple and that a Joy street in Belfast may possibly be named after the same family after they went to Ireland.

## Juhel

Juhel de Totnes (other spellings are Judael, Judhael or Joel) was a nobleman and supporter of William the Conqueror (1066–87). He was born in either Brittany or northern France and was the son of Alfred. He had been granted the feudal baron of Totnes by William, as well as more than 100 manors in Devon by the time of the Domesday Book in 1086. In around 1087 he founded Totnes Priory. At some point before 1100 Juhel was granted the large feudal barony of Barnstaple, which he made his home. He died in 1130 aged over eighty years old.

Joy Street, Barnstaple.

## Kilns

In the eighteenth and nineteenth centuries there were several limekilns in the Barnstaple area, as well as around the North Devon coast. Limestone and coal were imported (mainly from south Wales) and the quicklime produced by the kilns was transported to farms to improve the soil. There were eight limekilns between

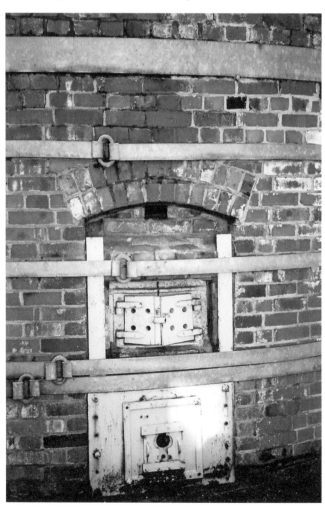

Brannam's pottery kiln, still in the garden of Litchdon Street Medical Centre.

Barnstaple and Bishop's Tawton, including one in the middle of what is now Rock Park. There were also limekilns near The Square, although these were removed in the 1840s. In 1879, the *North Devon Journal* remarked that the close vicinity of limekilns had been 'neither agreeable to the eye nor fragrant'. There have also been many pottery kilns in Barnstaple and one of Brannam's bottle kilns can be seen behind the medical centre in Litchdon Street. A reconstructed seventeenth-century kiln from the library car park site can be seen in the museum.

## Knapp House

Thomas Benson inherited the large family fortune and estate at Knapp House, Northam, in 1743 aged thirty-six. He became MP for Barnstaple in 1747 after presenting the council with a magnificent silver punch bowl (still on display in the Dodderidge Room of Barnstaple Guildhall). Bribery was quite normal in elections at this time, with prospective candidates offering gifts or money. In the same year Benson was awarded a government contract to transport convicted criminals to the colonies; however, he also had the lease on the small island of Lundy only 20 miles off the North Devon coast, and it was here that Benson shipped the convicts that he had been paid to take to America. They were used as slave labour on the island (the sewer system on the island, among other things, was built using slave labour) while Benson himself became increasingly wealthy.

Finally, after insuring a ship filled with cargo then secretly unloading and scuttling the ship, Benson was caught out and fled to Lisbon, where he started over again. He died in 1771 after building up one of the largest trading companies in Portugal.

## Knight, R. L.

There are many photographs and postcards showing Barnstaple in the early and middle years of the twentieth century from Knight's photographers. The business began in March 1912 when the *North Devon Journal* announced the transfer of the fifteen-year-old photographic business of Messrs Major, Darker and Loraine at No. 78 High Street, Barnstaple, to Mr R. L. Knight, who had also purchased the stock of Mr Walter Wood of the Bear Street Studio. In 1927, R. L. Knight was advertising 'Photographic Demonstrations and Continuous Cinema Exhibition' at the Model Ideal Exhibition at what was then called the Albert Hall, Barnstaple. Writing in the *North Devon Journal* in 1946, a journalist from Chichester, recalling his early years in Barnstaple, wrote about the enterprise of R. L. Knight: 'I was roused to admiration for his ability and efficiency of photographic production in the provision of scenes at the Guildhall Fair ceremony, the street scenes and later in the week the Hospital Carnival. Truly I have never known smarter photographic catering.'

## Lace Industry

Barnstaple's lace industry has been largely forgotten, but in the first half of the nineteenth century there were three lace factories in the town. The most obscure is the factory at Newport, established in 1825 'on the marsh nearly opposite the Infirmary on the Newport Road'. It was not very successful and, unlike the other two factories, did not reopen following closure in May 1837 due to market conditions. The factory was eventually demolished and its remains are probably buried under Rock Park. In 1822, John Boden and Thomas Heathcoat opened the first lace factory in a derelict woollen factory at Rawleigh, Pilton. There were many problems with the business and in 1844 it closed. The most successful business was the third factory at Derby, then usually known as Stoneybridge. Built in 1825, the factory was taken over by Miller & Co. three years later. John Miller built Gorwell House for himself and his family, but died aged fifty-five. His wife had died a few months earlier and the house was sold.

In 1863, the running of the factory was taken over by three of Mr Miller's sons: John May Miller, William Walter Miller and Alfred H. Miller. John May Miller became

Panoramic view of Barnstaple in the 1920s.

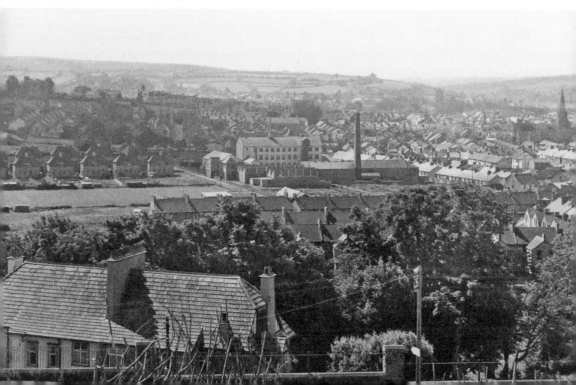

mayor of Barnstaple. Business declined in the 1860s, but by 1874 it had improved and a new wing was added to the factory. In 1900, the foundation of the Miller Institute was laid to provide reading and recreational rooms, a concert hall and ornamental gardens. In May 1903 the last of the three brothers died. The factory closed in 1929 and was sold to Messrs Small and Tidmas. The Miller Institute eventually became the Barnstaple Boys' Secondary School and then Yeo Valley Primary School.

## Lauder, Alexander

In 1876, Alexander Lauder, an architect who later became mayor, and his brother-in-law W. O. Smith founded the Devon Art Pottery. The firm made bricks (which were used in the Shapland and Petter building) and also produced flowerpots, umbrella stands and other items. They also owned several limekilns along the Taw. Smith later went into partnership with Michael Squire, an agricultural implement merchant and whose showrooms in Tuly Street were later designed by Lauder and completed in 1903. The façade of this building still stands today, with the terracotta reliefs depicting ploughing and reaping scenes.

## Lee, Frederick Richard

Frederick Richard Lee was a painter born in Barnstaple in 1798. He became a professional artist and exhibited regularly in London until 1870. He painted landscapes and sometimes collaborated with other painters, including Landseer, who painted the figures and animals. He lived at Broadgate House, Pilton, but spent a lot of time travelling the world on his yacht. He died in 1879.

The façade of the agricultural implement merchant's building designed by Lauder in 1903.

Pilton in the early 1900s

# Lethaby, William Richard

William Richard Lethaby was born in Barnstaple in 1857 and educated in the town before leaving at the age of twenty-one to pursue a career in architecture. His father was Richard Pyle Lethaby, who was a skilled carver and gilder and lay preacher at the Bible Christian Chapel. William grew up in a religious, but politically radical, household. He attended the grammar school but did not enjoy academic subjects, writing: 'Arithmetic and grammar and what they call history were horrid bores and mostly gibberish to me'. His particular abilities emerged when he began night classes in drawing at the Barnstaple Literary and Scientific Institute, where he did well and won prizes. At the age of fourteen he was apprenticed to the architect, artist and potter Alexander Lauder. Lethaby left Barnstaple when he was twenty-one and in 1879 settled in London as chief assistant to the successful country house architect Norman Shaw for ten years. He was involved in designing such famous buildings as New Scotland Yard and Craigside, Northumberland. He was part of the Arts and Crafts movement and his design of the village church (1901–02) at Brockhampton, Herefordshire, is regarded as one of its greatest monuments. He became joint director of London's new Central School of Arts and Crafts and in 1900 he was appointed professor of ornament and design at the Royal College of Art. For many years he was also surveyor to the fabric of Westminster Abbey, where his policy of mending and cleaning resulted in the discovery of many hidden treasures including medieval carvings and wall paintings. He died in 1931 and is buried in the churchyard of Hartley Whitney, near his country house in Hampshire. He was almost forgotten until the 1970s when he became viewed as the formative influence on British twentieth-century design.

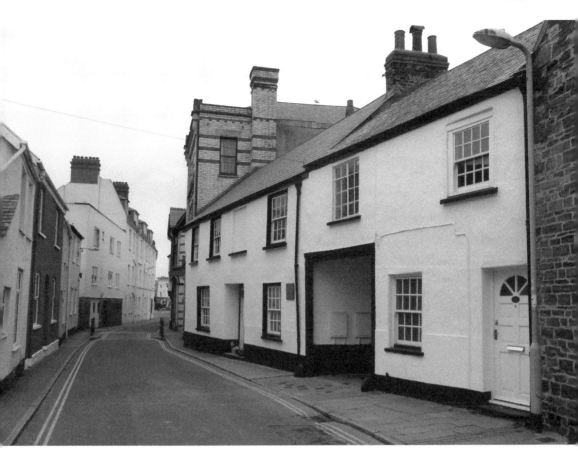

Litchdon Street, once the main road to London and Exeter.

## Litchdon Street

Once the main road out of Barnstaple to Exeter, it is recorded as Lycheton in 1370 and Lychedon in 1550. The meaning is obscure, but believed to be from 'lic-tun' – a cemetery, possibly because it was near an unknown old burial ground. An article in the local paper in 1941 suggested it was from 'Lidwichton', meaning 'farm of the Breton'.

## Literary and Scientific Institution

William Rock's first gift to the town was in 1845 when he set up the Literary and Scientific Institution in the High Street, which he endowed with £100 a year so that those people not otherwise able to afford the annual subscription could use its facilities. These included a lecture room, a museum and two reading rooms to which Rock donated large parcels of books each year.

## Maiden Street

The origin of the name Maiden Street has given rise to several theories. It may be a corruption of 'midden' and mark a rubbish dump or the place where the town sewer entered the river. That seems the most likely origin, but other suggestions are that it was the place where maidens came to collect water or that maidens provided money for the Maiden Arches of the bridge, which are the three arches nearest the town and were added or replaced during the sixteenth century.

## Market Street

This is a comparatively new name, introduced following the construction of the Pannier Market. For centuries, right up into the twentieth century, it was called Anchor Lane. The derivation is uncertain, but it may be because an anchorite, or hermit, lived there.

## Market, Pannier

Barnstaple's Pannier Market is another example of the work of borough architect R. D. Gould. Markets had previously been held along part of the High Street, but it was decided a more organised and cleaner option was needed.

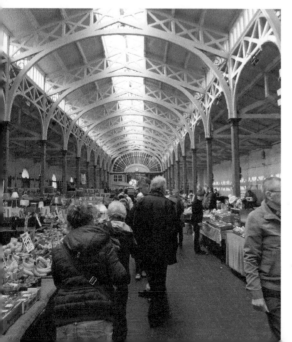

The Pannier Market today.

The scheme involved the demolition of a large number of houses and made use of the site that was previously a slaughterhouse and Corn Market. The construction of the Pannier Market was not without some controversy: the size of the planned market was considered too large and there were fears of it all turning into something of a white elephant. The area covers the entire length from the High Street to Boutport Street. The Pannier Market, however, was a success from the start and continues to be popular. Officially opened on 2 November 1855, W. F. Gardiner described it as a 'red-letter day in the commercial and domestic history of Barnstaple'. The works were carried by R. Gribble, joiner and builder; James Bowden, plasterer; J. Pulsford, stone mason; J. S. Clarke, painter and glazier; and Lancey & Sons, plumbers. The final cost amounted to just under £7,000.

## Mazzards

Mazzards are a local variety of cherry that were once grown in considerable numbers. In 1833, a close of land or mazzard garden of around 4 acres was offered for sale at Landkey, where most of the fruit was grown; it contained 110 mazzard trees and ninety-eight apple trees. Mazzards were regularly sold in the local markets. In Barnstaple market in August 1854 mazzards were sold for 2$d$ per lb. Early in the twentieth century there were over 100 acres of orchards around Landkey, many of which were mazzards. By the 1990s they had almost disappeared, but funding was obtained from the Millennium Commission and new orchards established on the Landkey Millennium Green, which are now flourishing.

Mazzard cherries, a once famous local variety.

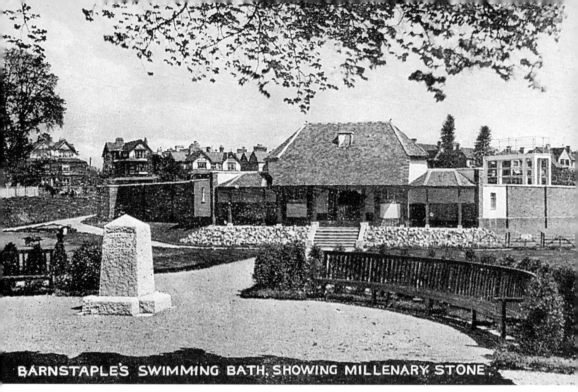

BARNSTAPLE'S SWIMMING BATH, SHOWING MILLENARY STONE.

The Millennium Stone, Rock Park.

## Millenary Stone

In 1930, millennium celebrations were held in Barnstaple, commemorating 1,000 years of the town's existence. Culminating in the erection of the Millenary Stone in Rock Park, the activities took place over four days in August to coincide with the holiday season. A ball was held in Bromley's restaurant and there were also processions, sporting events and music concerts. Strings of coloured lights decorated the riverbanks and the festivities ended with a fireworks display. However, the traditional belief that King Aethelstan gave Barnstaple its first charter in AD 930 is now believed to have been untrue. Recent historians are currently of the opinion that the charter probably never existed.

## Mint

By the time of the reign of King Aethelstan (AD 924–27), Barnstaple was sufficiently established to be granted the right to mint coins. The earliest surviving example currently in existence are from the reign of Eadwig (AD 955–59). The mint finally ceased production in the 1120s.

# N

## Newport

Now a suburb of Barnstaple, Newport was once a separate town, founded by the Bishop of Exeter in 1295 on his manor lands in the parish of Bishop's Tawton. It was 1836 before Newport, together with Pilton, officially became part of the borough of Barnstaple. In medieval times Barnstaple and Newport were separated by marshes and watercourses, with no direct route between them. The first recorded mayor of Newport was John de la Pille in 1316. Several mayors lived at Pill (later Pill Farm and now Greendale) and Newport may have begun at a small port there. It is thought there was another small port at the point where Coney Gut entered the Taw. A medieval chapel at Newport was in ruins by the seventeenth century and became part of the Newport Borough Lands Trust.

The trust's income was used for various purposes, including repairing Coney Bridge at the end of Water Lane. The old chapel became a house and garden and later a barn, until in the early nineteenth century it was pulled down and No. 35 South Street built on the site. In 1829, a new chapel was constructed but various problems meant it was virtually rebuilt in 1882.

Until 1847 Newport was part of the ecclesiastical parish of Bishop's Tawton. The Duke of Bedford, the Chichester and Rolle families all owned land in Newport. It failed as a 'new town' and by the late eighteenth century Newport was referred to as a village. The main road was known as the 'Turnpike Road'. It continued to be referred to as a village well into the nineteenth century.

However, it was growing into a thriving community. Kelly's 1850 directory lists three public houses, three beerhouses, a master mariner, lime merchant, brick and tile manufacturer, wheelwright, two music teachers, a brush maker, cabinetmaker, gardener, milliner, tailor, surgeon dentist, maltster, stocking manufacturer and three shopkeepers, three bakers, two blacksmiths and four boot- and shoemakers and two farmers. There was a national school attended by 130 children. Several streets were built in the next half a century too, including Cyprus Terrace, Abyssinia Terrace, Gloucester Road, Victoria Street and Portland Street. By 1931 there were many more shops and services, including six dairies, a school of dancing and two motor works, but only two public houses. Trafalgar Lawn was established at the lower end of Newport in the 1820s on land purchased by Lewis Hole, who had been First Lieutenant of the Revenge at the Battle of Trafalgar. Victoria Road was formed in 1853 and in 1874 the Victoria Road railway station had opened linking Barnstaple and Taunton. Barnstaple's new grammar school was built in Newport in 1910 and the buildings are now part of Park School. The railway station, post office

and most shops have now vanished, but there is another school in Newport Road and residential properties continue to be built in the area.

## North Devon School

The North Devon School was a short-lived school in Trafalgar Lawn. The school was opened in January 1900 by Mr J. B. Challen who had been headmaster of Devon County School (later called West Buckland School). The school occupied the premises of a previous school run by Frank Townsend, but two additional properties were added to accommodate the numerous applications for places. No. 4 Trafalgar Lawn contained the chief classrooms and dormitories and No. 3 was the headmaster's residence and study. At No. 2 there was a book room and prefects' room, together with two large classrooms and a 'convalescent' room. According to the local paper, Mrs Challen had been immensely popular at West Buckland and was 'the directing genius of the household department'. There were eight dormitories containing fifty-two beds. The intention was to prepare pupils to go to public school and for the Army, Navy and civil service examinations, as well as for the universities. Although it was very successful, it closed in July 1910 when the new Barnstaple Grammar School opened.

## North Walk

North Walk was laid out in 1759 and further added to in 1812 when a long promenade of trees were planted along its length. In 1830, Gribble wrote in *Memorials of Barnstaple*: 'With its lofty and umbrageous trees, the river rippling around it, sometimes to its very

North Walk before the railway changed the layout.

edge, the exhilarating breeze from the tide, and the convenient access to it from different streets of the town – we shall not look upon its like again throughout the kingdom.'

North Walk remained a beautiful and admired walk until 1873, when the construction of Ilfracombe railway entirely changes that part of the town with the erection of an embankment and swing bridge. Today it is just a small stretch of road going up to the roundabout by Rolle Quay.

## Northgate

One of the four gates of early Barnstaple, the North Gate was not finally demolished until 1842, and even then there were some who regretted the destruction of old monuments. As the *North Devon Journal* put it, when reporting the opening of the new Blue Coat School in April 1844: 'Many of our townsmen ... could not repress a sigh at the remembrance of the relics which this utilitarian age refused to spare.' The report went on to point out it had been the incentive for the 'prettiest and best additions which the town has acquired for many a year,' referring to the new Blue Coat school that had previously been held in 'an inconvenient room' over the North Gate. It was the trustees of the school who had requested the demolition, but it was generally agreed to be a good thing.

The date of construction of the walls and gates of early Barnstaple is unknown, but they were in existence by the time of Juhel's charter in 1107. Above or adjoining the North Gate had been a chapel dedicated to All Hallows or All Saints. The gate had consisted of two circular arches with a central pier, although by 1842 only the eastern arch remained intact. The arch was semicircular and the central pier was around 4 feet thick and constructed of massive rough stones, which led to a suggestion in the nineteenth century that it was Roman work; however, as there is no evidence that the Romans had a settlement in the area, the idea has long since been discounted. For many centuries the section of High Street from Holland Street to the gate was known as North or Northgate Street, as the other end of the High Street was known as Southgate Street. Writing in 1882, Chanter noted that until very recent times Northgate Street was entirely occupied by private residences, some of them bearing evidences of considerable grandeur in early times.

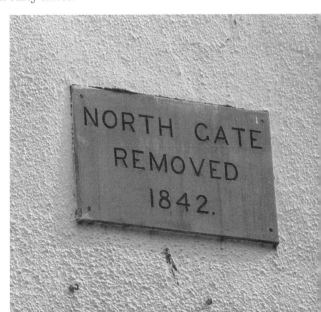

Plaque on the site of the North Gate.

## Oliver, Bruce

Bruce Oliver was a prominent architect in Barnstaple and Bideford. Born in 1883, he had a keen interest in local history and was one of the instigators of the millennium celebrations in 1930. Mayor in 1931, he died in 1976. His father, William Clement Oliver, was also an architect and designed the Shapland and Petter building.

## Organ

One of the best examples of a large ecclesiastical organ can be found in St Peter's Parish Church. It was originally presented to St Peter's in 1754 by Sir John Amyand, MP for Barnstaple. He was a friend of Handel, who may have recommended the organ builder John Crang. Crang, born in Devon and one of the greatest organ makers of his day, was responsible for maintaining the organ at London's Foundling Hospital, for which Handel composed music. During the Victorian alterations to the church, the organ was moved from its original position and damaged. In the following century various repairs were made, but a major restoration was carried out in the 1990s.

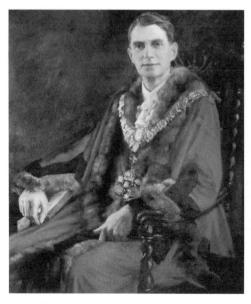

*Above left*: Bruce Oliver, architect and mayor in 1931.

*Above right*: The eighteenth-century John Crang organ in St Peter's Parish Church.

# P

## Palmer, William

In the summer of 1645, Ann Fanshawe was the guest of William Palmer. She stayed in Barnstaple for a few weeks as part of the entourage of Charles, Prince of Wales and later Charles II. They had travelled there to escape the plague at his former headquarters in Bristol. She later remembered that she saw a parrot over 100 years old at Mr Palmer's house. William Palmer may well have acquired a parrot – whatever its age – as by that time he had been a merchant for over twenty years, importing and exporting various items around the world. His date of birth is uncertain, but it must have been during the reign of Elizabeth I as by 1604 he was working for the famous Barnstaple merchant John Delbridge. Delbridge reported to the Secretary of State, William Cecil, that he had heard from 'Palmer at St John de Luz that the French king has sent an ambassador to the king of Spain. The Spaniards are gathering Companies in Castile and Andalusia and purchasing ships. They hear of a fleet preparing in England, and so have sent two ships from the Groyne to run on our coast and learn its proceedings...' Delbridge and Palmer were part of a chain of agents who kept Cecil informed and, although there is no mention of payment for such information, it is possible that he made it easier for those involved to obtain export licences or exemption from government embargoes on shipping. By the time he died in 1653, William Palmer was one of Barnstaple's wealthiest merchants and had been mayor two or three times. Perhaps it was unfortunate that he was mayor in 1642/3 as that put him in a position of responsibility at the time of the Civil War – not something he likely would have welcomed. He was one of those who provided funds towards the town's defences and was a member of the War Council, which met every day in the Guildhall.

In September 1643, when the Royalists were winning in the west, he surrendered the town to Colonel Digby – a Royalist. There were some suggestions (by Parliamentarians) that the surrender was a betrayal, but this is unlikely – in the circumstances, he had little choice. As Mayor Palmer had to entertain Digby, the borough records note he was allowed expenses 'in entertayninge of Colonel Digby and his company here xi days'. There was also 'iiijs viid paid for Wyne bestowed in entertayninge of seven captaines and gentlemen by Mr Maior att Mr Downe's house'.

William Palmer had a reputation for honesty and was a friend of John Penrose, who said in his will of 1624 that he found his friend William Palmer a most wise and upright dealer and just in all his accounts and reckonings. Penrose left each of Palmer's eight children £30, to be given to them when they reached the age of twenty-one. In his own will, nearly twenty years later, Palmer refers to his five sons – William,

Anthony, Richard, John and Edward. He only refers to one daughter, who had married John Martin of Plymouth, so perhaps the other two had died. His will mentions several streets in which he owned or had an interest in properties, including High Street, Green Lane, Maiden Street, Bear Street and Boutport Street in Barnstaple. Properties in Bishop's Tawton, Lynton, Yelland, Swimbridge and Fremington are also noted. A list of shipping from 1626 records that William Palmer was part owner of two ships: the *Golden Lyon*, in partnership with Penticost Dodderidge, William Gaymon, Richard Medford and Henry Mason, and the *Antelope* with Lewis Downe and Nicholas Garland.

It seems one of his enterprises was trading in beaver pelts with the New Plymouth colony founded by the *Mayflower* emigrants. This was a new trade and important for the colony's survival. In 1628, 2,000 beaver pelts arrived and were sold in London for making hats. In 1657, a curious note in the borough records states that Anthony and John, two of Palmer's sons, were 'not to pay interest for £100 on account of good services to Town by William Palmer'. No more details are given but it seems likely this relates to the Civil War period.

## Parish Church

It is not known exactly when the Parish Church of St Peter's was built, but the first vicar was recorded in 1257. However, in the following fifty years the church must have been rebuilt, as the present building was reconsecrated by Bishop Stapledon of Exeter in 1318.

St Peter's Parish Church.

Edward VII stained-glass window, St Peter's Church.

Since then there have been many alterations and repairs, which has considerably altered the original design. Reconstruction work was undertaken by Sir Gilbert Scott in the second half of the nineteenth century, when the church was found to be urgently in need of work to make it safe. By the end of the nineteenth century the church had been restored, but the interior had been greatly changed. The twisted spire is a feature of the church clearly visible from the ground. The spire was added in the 1380s, although has been much repaired since. It was struck by lightning in 1810, but the twisted appearance probably results from the lead warping in the heat of the sun.

## Park Lane

Although it was not called Park Lane until after the creation of Rock Park, this lane does seem to have existed for centuries, being called Slimey Lane or Slymlane, possibly because it led down to a limekiln. It was also called South Lane for a while before becoming Park Lane.

## Paternoster Row

The name of Paternoster makes it clear this is an area near the church, as it is Latin for 'Our Father', the first words of the Lord's Prayer. Exactly which area it refers to, however, has been a matter of uncertainty. It is now usually applied to the road through the centre of the churchyard from Boutport Street to High Street, although it may only refer to the cobbled area at the eastern end from Boutport Street to the iron gates. A reporter writing in the local paper in 1941 referred to it as 'the Boutport Street entrance to God's Acre', but thought that the name had dropped out of use and that a large proportion of Barumites would display ignorance of its location.

Paternoster Row Gates, 1950.

## Pearces Restaurant

This was the name by which the popular Borough Restaurant was known locally during the first half of the twentieth century when it was owned by the Pearce family. They were also confectioners and bakers, which is how the business began when H. Ballenger placed an advert in the *North Devon Journal* in July 1875 announcing that he had opened large and extensive premises at No. 97 High Street, Barnstaple, adjoining the *North Devon Journal* offices. The premises were advertised as a bread and flour warehouse, supplying families with 'superior Bread and Cake, Tea Cake, Dinner Rolls, etc etc'. He was also an agent for Huntley and Palmer biscuits. By 1888 his business was called the Borough Restaurant when he published *A Bijou Guide to Barnstaple* with Goodacre Bros., a booklet designed for tourists. In 1892, the business was taken over by J. Chappell, who, as well as being a confectioner, fancy bread and biscuit manufacturer, also advertised extensive dining rooms for large or small parties, hot and cold luncheons, teas, etc. By 1901 it belonged to Thomas A. Pearce, who also owned Model Steam Bakery at No. 65 Newport Road, which remained in the Pearce family until the 1950s. The Pearce family's Newport bakery was established in 1827. An article on the shops at Christmas in the *North Devon Journal* in December 1907 mentioned that Mr Pearce's display 'is on the customary lavish scale ... a large Xmas cake lit by electricity in the High Street window is a great attraction'.

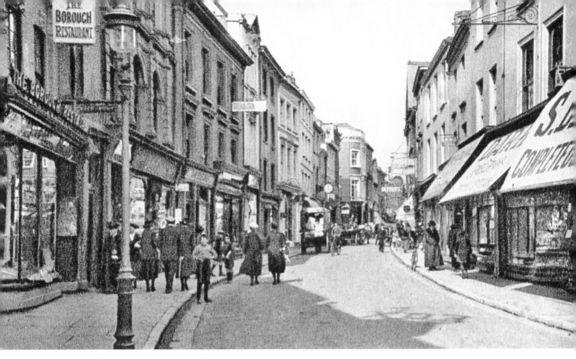

The Borough Restaurant, Barnstaple High Street.

## Peard, George

George Peard was one of the numerous Peard family of North Devon. He was Recorder and MP for Barnstaple at the beginning of the Civil War, when the House of Commons granted him leave of absence to return to Barnstaple and strengthen the inhabitants' support for the Parliamentary cause. He was hated by the Royalists who regarded him as the ringleader of the Parliamentarians in Barnstaple and referred to 'the petulancy of Master Peard (that prudent, learned and comely Gentleman)'. They also called Barnstaple 'Master Peard's nest'. A Parliamentary report in February/March 1644 stated that the mayor, who was also a member of the Peard family, and George Peard were badly treated and imprisoned in Exeter. They were released but George Peard, who was already ill, died between June 1644 and March 1645. Not surprisingly, there were rumours that his ill-treatment at the hands of the Royalists might have contributed to his early death. He was said to be a 'vehement speaker', but moderate and sober in his views.

## Penrose, John

John Penrose was a local cloth merchant and mayor. When he died in 1624 he left directions in his will that his executors were to buy 'some convenient place fit to erect an alms house upon'. The inhabitants had to be from Barnstaple and should be God-fearing and non-drinkers. There are twenty dwellings, each for two people, with a small garden plot at the back (now allotments). There is a chapel at one end and a meeting room at the other. The door of the meeting room had bullet holes, apparently the result of a skirmish during the Civil War. The cobbled courtyard with its water pump is visible from the street. The appearance of the almshouses has hardly changed over the centuries, although they have been modernised and brought up to date inside. The central entrance has granite pillars – note the carved initials on the door posts into the courtyard.

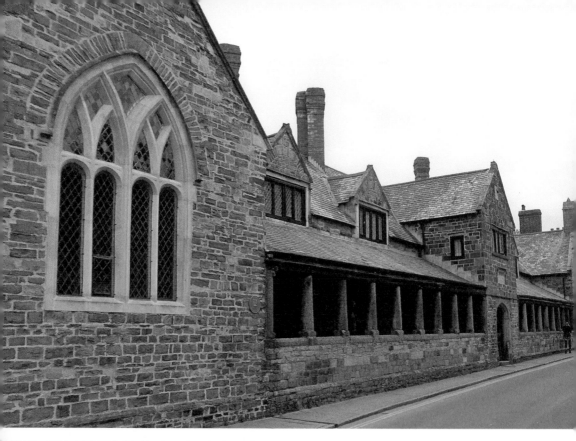

*Above*: Penrose Almshouses, Litchdon Street.

*Left*: Civil War bullet holes in the meeting room door, Penrose Almshouses.

## Pewter and Pewterers

Pewter goods were used in most households from the late medieval period well into the eighteenth century. Thomas Pewterer was living in Barnstaple in 1343, and the town became an important centre of pewtering. Several Barnstaple pewter makers also worked in brass and lead and described themselves as braziers or plumbers. The Webbers were a prominent family, with five members involved in the craft from around 1630–1739. Five pewterers became mayor, including Marshall Swayne who was mayor in 1746 and whose portrait is in the Guildhall along with a portrait of Alexander Webber, who was mayor in 1727. His father John Webber was also mayor, together with Nicholas Sheppard and Thomas Cooper. Large exports of pewter were sent to the North American colonies as well as to Ireland and Europe.

## Pilton

Pilton, now just a suburb of Barnstaple, was once a separate and distinctly different village, and it has been a matter of much debate over the years as to which is the older of the two. Pilton was an important Saxon settlement and according to the Burghal Hidage (a document believed to have been created between AD 911 and AD 914 that lists thirty-three of King Alfred's burghs), Pilton's wall was 1,485 feet long with a garrison consisting of 360 men. The Benedictine Priory in Pilton was founded in the twelfth century, but large parts of it were demolished after the Reformation.

In the thirteenth century, Pilton and Barnstaple were separated by a hazardous marshy ground and the tidal waters of the River Yeo; this was to change, however, with the construction of Pilton Causeway in the fourteenth century.

A fair and market were granted to Pilton by Edward III in 1344, with the wool trade flourishing throughout the medieval periods; later, glove making and agriculture took over. Gradually, both Barnstaple and Pilton grew and became one place, although Pilton still maintains its unique personality and sense of community.

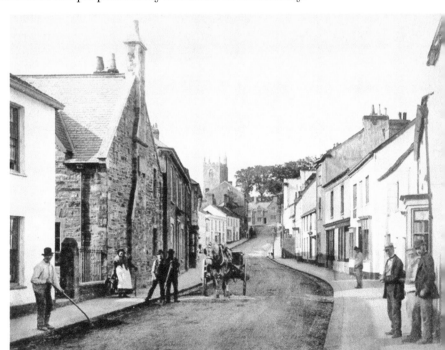

Pilton High Street, 1910.

Part of the Millennium Mosaic depicting the trade in pottery.

## Pipes and Pipemakers

Clay pipes have been produced in Barnstaple for centuries. The earliest pipe-maker was probably Peter Takell, a potter working in the castle area. In 1628, he entered into a bond to pay off a debt in 'good tobacko-pipes' at 9*d* a gross. A pipe likely to have been made before 1640 with the initials 'PT' has been found in the area. He died in 1637 and may have been the first potter working in the castle area. One of the last clay pipe factories in the country, along with hundreds of broken pipes, was discovered by archaeologists at Alexandra Road during excavations in 1986. This was the factory of John Seldon & Son, which opened in 1859 and closed twenty years later. The pipes were made from Fremington clay or Marland clay from Torrington. They were often bought and given away for free by public houses, with some pipes having ornate designs and long stems.

## Post Offices

In the early 1830s Barnstaple had its first post office. Before this there had only been two postal deliveries a week. Situated at the end of Cross Street, the postmistress was a Miss Jones. There was a small window where business was transacted, with the public standing in the street. A few years later, the post office was moved to Boutport Street and then, later still, to No. 88 High Street. With the introduction of the penny post, this quickly became too small and so it was moved back to Cross Street but given a larger building. Eventually, in 1902, a large purpose-built post office was erected on the site of the recently demolished house of Pentecost Dodderidge. This building can still be seen and is now Slee Blackwell Solicitors.

The Old Post Office, Cross Street.

## Potters Lane

This lane disappeared when the new library was built. It was also called Castle Lane and ran parallel to Tuly Street from near the castle mound to what used to be Potters' Quay.

## Public Houses

Until the Licencing Act of 1869 the term 'public house' was a loose one. As well as established premises, any private house could sell alcohol. It is therefore impossible to say exactly how many of Barnstaple's numerous listed public houses in the nineteenth century were actually licenced ones. A list from 1837 carried names of eighty-one drinking establishments, a staggering amount for the size of the town at the time, which had a population of little over 6,500.

In the 1820s the High Street was listed as having thirteen public houses, with one either side the old Guildhall – the Jolly Butcher and the Boar's Head. Three pubs and a brewery were demolished to build Bridge Buildings on The Square, with another three similarly demolished to build Bridge Chambers on the opposite side of the road thirty-five years later. Anchor Lane (now Market Street) had a staggering seven pubs along its short length, with another, the White Heart, looking down the lane from Joy Street.

Needless to say, in the mid-1800s a non-drinker was considered an oddity. It was only with the emergence of the temperance movement in the 1880s that the prevalence of public houses started to change. The Licencing Act and continuing town improvements similarly led to great changes.

## Quay Station

Barnstaple Quay station opened in 1874 when the L&SWR line was extended to Ilfracombe. Situated close to Queen Anne's Walk, when the Lynton line opened just over twenty years later, Quay station was too narrow to take another line so a new station was built further along Castle Street and was known as Town station. Quay station was soon demolished with the old bus station being built on the site in 1922.

## Queen Anne's Walk

A merchants' walk, or exchange, has existed here since the seventeenth century, with early maps showing the site standing alone jutting into the river. The prosperous merchants who would spend their time here all put money towards the building of a sheltered area to offer some protection from rain and wind when carrying out

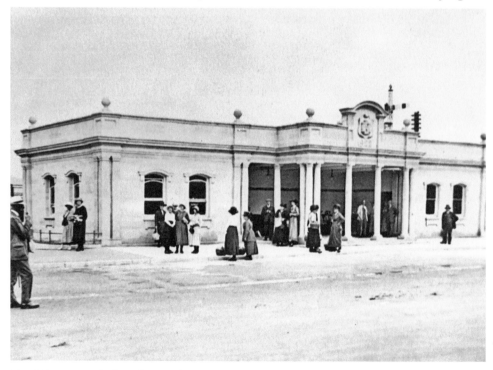

The old bus station, built on the site of Quay station in 1922.

*Above*: Queen Anne's Walk.

*Right*: Master's Chair, Masonic lodge.

their business by the quay. The colonnade that can be seen today was a second more elaborate construction. It was erected in around 1708, with the statue of Queen Anne (the reigning sovereign at the time) added shortly after and given by Richard Rolle. The heraldic crests of those who contributed can be seen carved into the façade either side of the central statue of the queen.

The building behind, which is entered via the colonnade, was built in 1858 as a public bathhouse. The premises included a small swimming pool, several hot- and cold-water baths, and wash houses. The idea being that householders could make use of the facilities provided. However, this business was not a success and the company collapsed after ten years. The premises were then acquired by the Freemasons and converted into a Masonic lodge.

# Queen Street

Another street that has changed its name. Known for centuries simply as Back Lane, in 1851 the residents petitioned the council to change this and so it acquired the rather grander name of Queen Street.

# Quick Family

There were several families of silversmiths in Barnstaple from the late sixteenth century to the early eighteenth century and the Quicks were one such family. By 1573 Peter Quick was in business and living in Cross Street, although by the time of his death in 1610 he had a shop on the quay. His sons, another Peter and a John Quick, carried on the business, but little is known of them and they are not recorded at the time the London wardens visited the town in 1633. Several spoons of the highly decorated and unique Barnstaple type exist with 'IQ' as a mark, which are believed to be by John Quick. There were also two Peards who worked in silver later in the seventeenth century. John Peard was the son of Charles Peard, who was mayor in 1643 followed by his son, John Peard. Late in the seventeenth century the Servant family (Huguenot refugees and originally named Servante) settled in Bideford and then in Barnstaple, and were very successful silversmiths.

# Raleigh

Raleigh, the usual spelling of which was Rawleigh, but also Raleghe, Rawley and Rayleigh, was one of the four manorial estates that form modern Pilton. The others were Pilland, Pilton and Bradiford. By 1166 Hugh de Raleghe was using the name of the manor as his personal name. In 1377, the heiress of the Raleighs was Thomasia and her marriage to Sir John Chichester brought the estate into the Chichester family. The North Devon District Hospital is on the site of the Chichester family's mansion, which according to the Hearth Tax Return of 1664, had twenty-four fireplaces. Around this time the Chichesters moved to their property at Youlston and sold Raleigh to Barnstaple merchant and MP Arthur Champneys, who later sold it to another MP, Nicholas Hooper, whose son built a smaller house on an adjacent site.

There were several industries associated with Raleigh, including corn and fulling mills in earlier centuries. In 1774, a woollen manufactory was built there, but following a fire it closed in 1795. A bobbin net factory was established in the remains of the factory in 1821 by Mr Boden and Thomas Heathcote. In 1825, Heathcote opened the first lace factory at Barnstaple. The Raleigh factory continued for several years, but then became Frederick Maunder's factory for washing, sorting and combing wool, which was sent to other parts of the country for manufacture. In 1851, a single room at Mr Maunder's factory was occupied by Henry Shapland, who with one employee produced high-quality ornamental cabinet work. Retired publisher Henry Petter joined him and for a while they operated from Bear Street, Barnstaple, before returning to the Raleigh factory in 1864, by which time Mr Maunder had moved into the old workhouse in Tuly Street. The Raleigh Cabinet Works were very successful and the factory continued to operate there until it was burnt down in March 1888. The factory was rebuilt on the site near Barnstaple Long Bridge where it remained until it closed.

# Rawle, Gammon and Baker (RGB)

Another successful business that grew up on the Pilton side of town and still survives was founded in 1850 as the timber merchant's business of Rawle and Gammon. The firm began chartering its own ships to import timber in 1855. It appears they took emigrants to Quebec on the outward journey, as a notice in the *North Devon Journal* for 1863 announced that the fast-sailing clipper barque *Ariadne* would sail from Rolle's Quay to Quebec on 4 April and would be taking passengers. Steerage passage cost £5 and the owners were Messrs Rawle and Gammon. Samuel Rawle was a lath maker and innkeeper of the Rolle Quay Inn and William Gammon was a builder. Frederick Baker was the son-

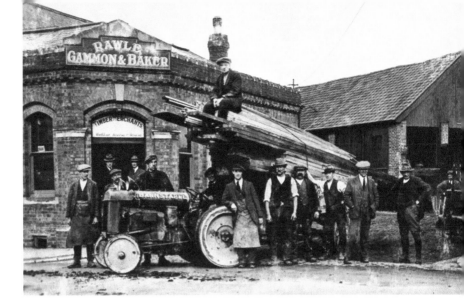

RGB timber merchants posing for a photo.

in-law of Samuel Rawle and joined the firm in 1879. In 1888, the local paper remarked on one of the latest improvements to that area of the town being the new offices of Messrs Rawle, Gammon and Baker, 'which stand on the site of the well-known sawpit which had done duty for over thirty years'. By that date the firm had steam saw mills, which had been nearly doubled in size to accommodate extra machinery for 'moulding, planning, grooving and tonguing, band-sawing, etc'. In 1928, Rock Trading Co. Ltd opened on the same premises, which dealt with bathroom equipment, fireplaces etc.

## Rock, W. F.

One man who has done more than most for his hometown was William Frederick Rock. Born in 1802, he made his fortune in the stationery business producing illustrated letter paper. Although Rock lived and worked in London he never forgot his hometown and remained a major benefactor and true philanthropist throughout his long life.

## Rolle Street

The names Rolle Street and Rolle Quay are a reminder that the Rolle family owned a great deal of property in Barnstaple, most of it formerly owned by Pilton Priory and acquired during the Reformation. Rolle Street was built in the late nineteenth century and the houses were almost certainly made of bricks from the nearby business of Lauder & Smith, established on land behind Rolle Quay.

## Rolle, Mark

The Hon. Mark George Kerr Rolle (1835–1907) of Stevenstone was High Sheriff of Devon in 1864 and High Steward of Barnstaple. He became the largest private landowner in Devon, owning 55,000 acres. He was a deeply Christian man and prolific philanthropist. His huge portrait from 1871 hangs in the Main Chamber of Barnstaple Guildhall. He was not a tall man and was said to be unhappy that the full-length portrait accentuated his diminutive stature, asking the artist to alter the painting. Unfortunately, the only way this could be carried out was to lengthen the legs, which had the result of creating an oddly out of proportion short body and overly long legs.

The Hon. Mark Rolle, painted in 1872 after alterations.

# Royal Visits

As far as we know there has only been one visit by a reigning monarch to Barnstaple and that was the visit in 1956 by our present Queen, Elizabeth II, three years after her coronation. She arrived at the Victoria Road railway station with Prince Philip and attended events at the Queen's Hall and Pannier Market. The gold pen with which she signed the visitors' book can still be seen in the Guildhall.

There have been two visits by future kings. The first was in June/July 1645 in the middle of the Civil War, when the fifteen-year-old Prince Charles, eldest son of Charles I and the future Charles II, stayed in Barnstaple for a few weeks when there was plague at his former headquarters in Bristol. He stayed with the wealthy widow Grace Beaple and was visited here by his cousin Prince Rupert, Richard Grenville and others to discuss the future of the war. It was here that he heard the news of the Royalist defeat at Naseby and he soon left the area, travelling to Cornwall and the Isles of Scilly before going into exile abroad.

The other future monarch was the eldest son of Queen Victoria, then known as Prince Albert although he took the name of Edward when he became king. He was also fifteen years of age when he unofficially visited North Devon in 1856. They visited Lynton and Ilfracombe and the next day hired ponies and rode to Barnstaple by way of Mortehoe, Woolacombe and Braunton before arriving in the town at around 1.30 p.m. They went to the Fortescue Arms Hotel for lunch and it was reported that the prince 'frequently appeared at the window of the hotel to view the crowd that the news of his presence had quickly gathered'. The royal visitor and his companions left Barnstaple on the 3 p.m. train to Exeter. Although his visit was short and has been long forgotten, there is one reminder in Barnstaple: the Fortescue Arms Hotel became the Royal and Fortescue Hotel, with the royal arms and Prince of Wales feathers added to the Fortescue Arms over the entrance.

Another child of Queen Victoria visited the town and stayed at the Imperial Hotel in September 1905. Princess Christian of Schleswig Holstein was Queen Victoria's third daughter, Helena, and she stayed here with her daughter. She visited the market and after seeing some blackberries there the princess requested that they be served at dinner that evening.

The royal crest above the door at the Royal and Fortescue Hotel.

# Russell, Revd Jack

One Sunday in 1861 the sermons at Lynton parish church were preached by Revd John Russell, vicar of Swimbridge. The collections were in aid of the North Devon Infirmary and came to a total of £23 15s 6d. Usually known as Jack Russell, the vicar of Swimbridge was the famous hunting parson who bred the terriers still known by his name. He was born in 1795 and educated at Blundell's School, Tiverton, and Exeter and Balliol Colleges in Oxford. He was ordained a priest in 1820 and in 1833 became vicar of Swimbridge where he remained until 1880, moving to the Rectory at Black Torrington until his death in 1883. He married the wealthy Penelope Bury of Swimbridge, whose sister Lucy was married to Stephen Bencraft, a leading figure in Barnstaple politics. Interested in agricultural improvement, he met the Prince of Wales (later Edward VII) at the Plymouth meeting of the Royal Agricultural Society. They became friends and Russell was invited to Sandringham on several occasions. He had many friends among the nobility and gentry families including Earl Fortescue and the Earl of Portsmouth. Although many Victorians did not approve of hunting parsons, Russell was widely liked and respected. He was once summoned by the Bishop of Exeter and accused of neglecting his parochial duties in favour of hunting, but the charge was proved false. It was said his sermons were often short and directed more towards reforming conduct than expounding doctrine. He denounced bad language, strong drinks and 'the filthy habit of smoking'.

He died at the age of eighty-seven on 28 April 1883. His funeral at Swimbridge was the largest remembered in North Devon, having over a thousand mourners. The Great Western Railway sent a special train from Barnstaple for those wishing to attend. The mayor of South Molton and mayor and town clerk of Barnstaple were among those present, as well as Viscount Ebrington and the Hon. Mark Rolle. The Prince of Wales sent a letter saying he and the princess mourned the loss of a personal friend and requested that a wreath of wild flowers be placed on the coffin on their behalf. The Revd Sabine Baring-Gould reported a comment on Jack Russell heard on a coach: 'He be very fond of dogs, I allow; he likes his bottle of port, I grant you that, but he's a proper gentleman and a Christian.'

## Shapland and Petter

In the nineteenth century, one of Barnstaple's major industries was furniture making. In the 1850s Mr Shapland set up a business in a small portion of an old woollen mill in Raleigh and was soon joined by Mr Petter, a retired publisher. The business grew and within a few years the firm acquired the entire factory. Later moving to a new site next to the Long Bridge, their first factory burnt down in March 1888 before the firm moved in. Rebuilding the following year, the factory was known as the New Raleigh Cabinet Works. Shapland and Petter furniture required a very high reputation with showrooms in Berners Street in London.

Shapland and Petter building.

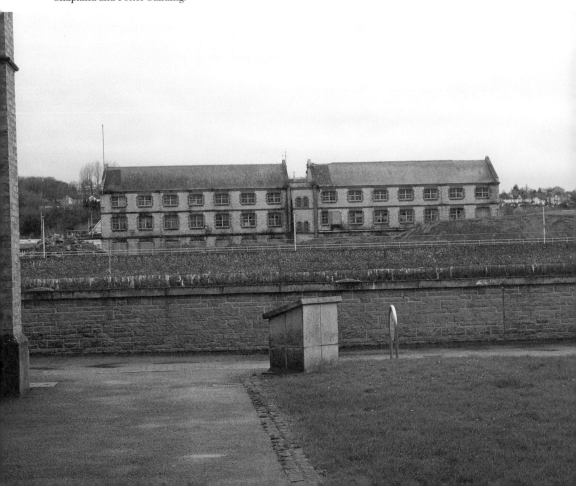

Remains of South Gate.

## Southgate

Both the South Gate and East Gate disappeared without being recorded, probably during the seventeenth century. A small portion of the stone is preserved in what is now Youings shop and the arches are believed to have been similar to those of the North and West Gates. This end of High Street was known as Southgate Street and it seems the earlier 'Tome Stone' was placed in this area as a deed of 1619 refers for payment 'to be made at the Tombstone at Southgate'.

## St Anne's Chapel

One of the oldest buildings in Barnstaple, St Anne's Chapel was built in the first half of the fourteenth century. The crypt, or undercroft, is the most ancient part and was used as a charnel house. The quadrangular porch, complete with gargoyles and a parapet, was added in around 1550. After the dissolution the chapel was used as a grammar

St Anne's Chapel.

school and John Gay, famous poet and playwright, was educated here in the 1690s. During this time French Huguenots were allowed to use it as a place of worship.

Services continued to take place until 1761 and then finally, in 1910, it also ceased being used as a school when a new grammar school was built in Newport.

## Stevenstone, HMS

Adopted by Barnstaple in 1942 as part of the Warship Weeks during the Second World War, HMS *Stevenstone* was a Hunter-class destroyer. She was a member of the third subgroup of the class and saw service during the war. All the ships of this class were named after British fox hunts. She was the first Royal Navy warship with this name – after the Stevenstone hunt in Devon.

Her royal ensign hung in Barnstaple Guildhall for many years, until it was replaced with a replica in 2003 when the original was thought to be too fragile for continuing display. A plaque hangs next to it commemorating the crew members who lost their lives. A few years ago a former crew member gave the town council a detailed model of HMS *Stevenstone*; it can be seen in the Dodderidge Room at the Guildhall.

## Sticklepath

Now a built-up area on the other side of the river, Sticklepath was undeveloped for centuries – with the exception of a few farms. The name means 'steep path', which anyone walking up Sticklepath Hill can understand! Travelling from Tawstock to Barnstaple at the end of the eighteenth century, Revd Swete remarked, 'the road brought us to Barnstaple, having (after its last descent) entered on the marshes, and on a mound raised above them, crossed the River Taw.' A new toll road replaced the old Sticklepath Hill in the early 1830s. Writing in 1935, Revd Albany Wrey remembered that when he was a boy a toll had to be paid at the toll gate at the bottom of Sticklepath Hill to drive into Barnstaple from Tawstock. As with the other marshy areas surrounding Barnstaple, flooding was a problem. In February 1846, it was reported that very high tides had rendered the road towards the Sticklepath toll gate impassable. It was proposed to build a culvert under it to prevent a recurrence. In 1886, the Royal North Devon Hussars assembled at Sticklepath for their annual eight days' training. There was a grand military tournament and the annual regimental shooting at the Anchor Wood Range.

The medical officer of health noted the growth of the area in his annual report for 1899. He reported that the number of births in Barnstaple had declined, but thought the explanation was probably the development of the Sticklepath estate following the establishment of the Bridge Wharf Works and the transfer of the old Rawleigh Works (Shapland and Petter) to that side of the river, as well as the proximity of the Junction Station. As he put it, 'a small colony has grown up ... in the shape of cottages occupied by men and their families who have migrated from the Urban to the Rural District.' This meant that births in these families were not included in Barnstaple's urban district figures. Sticklepath was, for many years, in the rural parish of Tawstock. In 1930, the *North Devon Journal* noted, 'what is virtually a new suburb has arisen on the slopes of the hill overlooking the river.' Sticklepath Hill was widened in 1930, probably partly as a work creation scheme as there was then much unemployment in the area.

Much new building took place in the 1930s. The long-established building firm of W. Woolaway & Sons produced a brochure for their Oakland Park estate, which covered more than 40 acres, setting out the history and attractions of the area. The most expensive property was a detached bungalow with three bedrooms, a dining room, drawing room and garage for £1,030. In October 1935 a stone-laying ceremony for a new Methodist church took place and the following year the Bishop of Exeter dedicated a new church on land provided by Sir Bourchier Wrey. The area continued to grow and in 1952 North Devon Technical College was opened at the top of Sticklepath Hill. Several alterations and extensions to the college have taken place since and, following the merger with East Devon College, it was renamed Petroc in 2009.

## Swan Inn

The Swan Inn in Holland Street was one of Barnstaple's oldest hostelries known to exist from the eighteenth century. It was originally sited on High Street with what was known as the Little Swan, which eventually became the Swan behind Holland Street. In 1837, the landlord was John Otway, but in September 1849 John Otway announced that he had left the Swan and gone to the newly built Golden Fleece in Tuly Street. In October that year William Slocombe announced that he had moved from the Barley Mow in Boutport Street (another public house that no longer exists) and moved to the Swan. He stated, 'AN ORDINARY will be provided on Friday the 5th of October at One o'clock, to be continued weekly, at 1s each.' An ordinary was a set meal at a set price. He also said, 'Families supplied with genuine Home-brewed beer.' The Swan remained in the Slocombe family until 1889, first run by William Slocombe then after his death in 1865 by his widow Mary Ann Slocombe and their son John Slocombe. Mary died at the Swan in 1881 aged seventy-one. There were several changes of landlord after 1889 and business seems to have dwindled until it was closed in 1934, when the landlord was Walter Moore.

Gammon Walk, leading from High Street to Tuly Street.

## Taw Vale

In 1846, a major change to the town plan took place when Taw Vale Parade was laid out. Prior to this there were no houses between the back of Litchdon Street and the river, the foreshore area being rough and untidy. It was decided a better approach road was needed from Exeter to London, and an improved appearance of the town from the riverside. Shortly after construction was finished, a grand terrace of houses was built, then at a town council meeting Councillor G. K. Cotton insisted that a road should be opened up between Litchdon Street and Taw Vale Parade in case of fire, so as water could be 'brought from the beach strait' to the affected area.

## Theatre/Theatre Lane

This narrow lane from High Street to the Strand is probably one of several ancient ways from High Street to the quay area, some of which have now been blocked up. It was called Theatre Lane following the opening of a theatre there in 1768. Before that it was usually called Honeypot Lane, but there are also references to Winter's Lane and Port Lane. The theatre closed in 1833. The Theatre Inn at No. 105 High Street on the corner of Theatre Lane continued until 1843. The site was later occupied by the well-known bakers and restaurant run by the Bromley family.

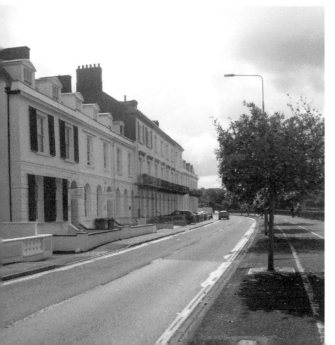

Taw Vale, which was laid out in 1846.

Tome Stone on Queen Anne's Walk.

## Tome Stone

The Tome Stone was placed on the quay in 1633 to replace an earlier stone. Merchants would seal their bargains here by placing their money on the stone, agree a price, and then shake hands before witnesses. Similar stones at Bristol and other places are called 'nails', hence the expression 'paying on the nail'. There are several names of merchants from that time engraved around the edge of the stone.

## Tourism

In 1862, the local paper noted, 'During the past summer the number of tourists to this locality was beyond precedent.' And in a letter to the paper in 1893 the local vicar mentioned, 'Many persons write to me as the Vicar of Barnstaple, to recommend comfortable apartments.' He points out all the advantages of Barnstaple as a tourist centre and the excursions that could be made from here including Lynton, Ilfracombe, Bideford, Clovelly, Instow, Appledore, Westward Ho!, Woolacombe, Mortehoe and Saunton Sands – many of these places were reachable by rail then, but although they no longer are, they all remain tourist attractions. Clearly tourism was well established by the mid-nineteenth century, encouraged by the arrival of the first railway station in Barnstaple in 1854. An early traveller called Richard Warner noted that even in 1800 in Ilfracombe there were 'some good houses chiefly for the accommodation of strangers in the summer season' lining the harbourside. He was a walking tourist, going on foot from Lynmouth to Ilfracombe and from Ilfracombe to Barnstaple. He noted that Barnstaple 'was the most genteel town in North Devon' and had balls every fortnight and a regular theatre. Tourism has continued to be important to the town. Barnstaple is not usually regarded as a health resort, but the annual report of the medical officer for the town noted in 1928 that Barnstaple was more popular than ever as such.

## Trinity Street

This was known as Second Back Lane until Back Lane became Queen Street in the mid-nineteenth century.

*Left*: Trinity Street, Barnstaple.

*Below*: Tuly Street, Barnstaple.

## Tuly Street

Previously Tooley Lane or Tooley Street. Unlikely as it may seem, this is a corruption of St Olave's and is named for St Olave's Well, which was in this area.

## Tunnels

There have long been stories of tunnels under Barnstaple, but none have been found. The museum carried out research in 2010 using a ground-penetrating radar and discovered several cellars, vaults and covered courtyards, but no tunnels. Although there have long been rumours about tunnels under the castle mound, the spaces under the mound relate to the icehouse dug out there in the nineteenth century and do not go anywhere.

## Turner, Joseph Mallord William

The artist J. M. W. Turner was born in London in 1775, but his father was born in South Molton in 1745. Both his grandfather and father were saddlers, although his father became a barber and wig-dresser and moved to London. Turner made a tour of the West Country in the summer of 1811 to prepare drawings for a book. Further tours followed in 1813 and 1814 and it is believed he visited his uncle, John Turner, who was master of the old Barnstaple workhouse in Tuly Street. He also visited his uncle in Exeter, Price Turner. Although Turner's connection with the area has long been forgotten, in 1852, following Turner's death the previous year, the *North Devon Journal* reported that Mr William Turner of Newport, formerly of High Street,

*Barnstaple Bridge at Sunset* by J. M. W. Turner, 1814.

was one of five first cousins of the famous artist and that he had other second and third cousins innumerable. The Tate Modern holds his painting *Barnstaple Bridge at Sunset* and a couple of sketches of Barnstaple from his tours.

## Turnpike Centre Stone

In the corner of Barnstaple Guildhall is the stone marking the spot from which the turnpike milestones take their measurements. It was decided to insert the stone at a meeting of the Barnstaple Turnpike Trustees in May 1879. Prior to this, mileage had been measured from different spots in the town and the markers had been wooden posts that were almost decayed. At the January 1880 meeting it was reported that the milestones and the centre stone had been obtained from Messrs J. Easton & Son, granite merchants of Exeter.

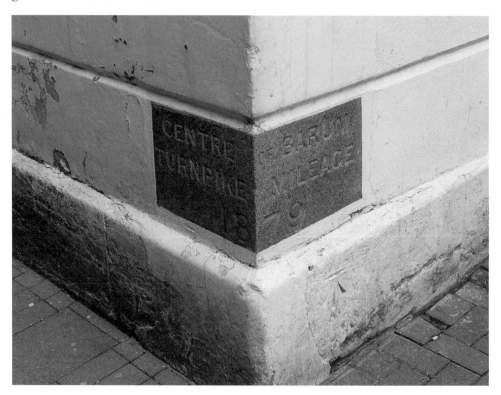

Turnpike centre stone in the corner of Barnstaple Guildhall.

# U

## Unicorn

The *Unicorn* was a Barnstaple ship of 60 tons owned by William Morcomb, or Morcombe. It was one of the merchant ships that went on reprisal voyages during the war with Spain at the end of the sixteenth century and was involved in the capture of three 'prizes' in 1589, 1590 and 1591. The cargoes in 1590 and 1591 were iron and sumac. William Morcomb may have been a part-owner, as legal proceedings were brought in 1590 by Robert Dodderidge against William Morcombe for withholding the profits of two ships sailing under letters of reprisal.

## Union Workhouse

The Barnstaple Union Workhouse was opened in 1837 at what is now Alexandra Road, but was then known as Shute Lane. It replaced the old workhouse in Tuly Street, which eventually became Dornats mineral water works. Barnstaple Union was large and included thirty-nine parishes including Atherington, Braunton, Fremington, Instow and Ilfracombe. By 1850 the workhouse had been enlarged and had room for 320 paupers, although it only had 220 inmates in January 1850. In 1849, its expenditure was £13,974. When the workhouse system ended the building became the Alexandra Hospital and when that was closed the buildings, except for the chapel, were demolished and flats built on the site.

Site of the first workhouse, now Barnstaple Library.

## Vicarage Lane

Named for the vicarage, which was rebuilt by Martin Blake in the mid-seventeenth century. This was once called Frog Lane, presumably from the number of frogs in this marshy area.

## Victoria Chambers

At the corner of Gammon Lane on the High Street stands Victoria Chambers. Opened in 1888, it was originally called Victoria Temperance Hotel and was one of four in the town. Temperance hotels were quite new at this time and became popular as the temperance movement gained support. It was under private management and lasted for just eleven years before being sold to Mr Chanter of Torquay.

For particulars see Bills.                    [8757

## — OPENING —

OF THE

# Victoria Temperance
# HALL,

63, HIGH STREET, BARNSTAPLE

A HIGH-CLASS

VOCAL & INSTRUMENTAL

## CONCERT

WILL BE HELD

On  WEDNESDAY,

JANUARY 23RD.

THE SERVICES OF THE

**LEADING ARTISTES** OF THE **NEIGHBOURHOOD**
HAVE BEEN SECURED.

FULL PARTICULARS,  SEE
POSTERS.

G. H. GOULD, Secretary,
VICTORIA TEMPERANCE HOTEL COMPANY.

Advert for the opening of Victoria Temperance Hotel, now called Victoria Chambers.

## Victoria Road

This is a surprisingly recent road, only having been in existence since 1853. For many years the road was used for the annual cattle fair, which together with the horse fair was part of Barnstaple Fair.

## Victorian Postboxes

The first roadside postboxes for use by the general public appeared in the British Isles in 1852 at St Hellier in Jersey at the recommendation of Anthony Trollope, who was working as a surveyor's clerk for the Post Office. Originally painted green, the famous 'pillar-box red' was adopted in 1884 to increase visibility. Most of the early postboxes have long gone, but there are two from the Victorian period still in existence in the Barnstaple area: one is in Newport, Barnstaple, and the other is along Church Street in Braunton. Clearly showing the 'V' for Victoria, they can be dated to after 1887, which is when the words 'Post Office' were placed either side of the aperture.

*Above*: Victorian postbox, Newport Barnstaple.

*Right*: An 1880s postbox at Braunton.

## Well Street

This is a surprisingly straightforward name and almost certainly refers to a well. Writing in the *North Devon Journal* in 1882, Chanter, who wrote several articles on Barnstaple's records and streets, referred to a deed he had seen from 1359 that mentioned a *'fons limpida'* – a fountain of fresh water. This presumably supplied the town pump, which he stated, 'within living memory stood in Boutport-Street, just opposite Well-street and was no doubt the origin of the name.' He also noted that it was a short street packed with small houses until they were gradually bought up and absorbed by the Fortescue Hotel.

## West Gate

The West Gate, or Water Gate, at the Strand end of Cross Street survived into the nineteenth century and was demolished in 1852. Although generally considered an improvement, there were a few who objected to the removal of this ancient monument. There were also a few who objected to spending £50 on the removal of the Quay Hall, or Kay Hall as it had long been known. The chapel of the medieval merchant guild of St Nicholas that adjoined the gate (the building of which had blocked one arch) was acquired by the Crown during the Reformation. It was eventually bought by the Corporation and used as a warehouse and store until its demolition.

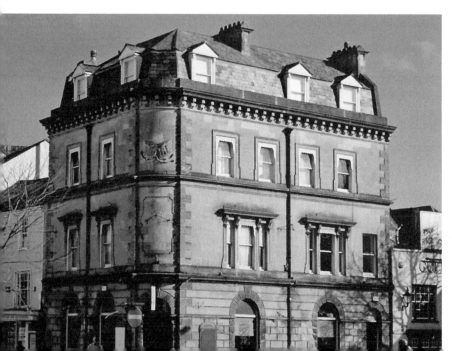

Once the Labour Exchange, then a bank, bookshop and restaurant.

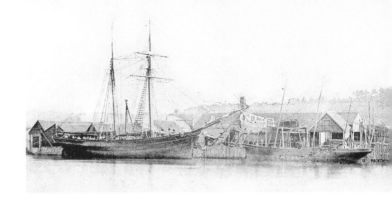
Westacott's Shipyard.

## Westacott's Shipyards

The main shipbuilding business in Barnstaple was Westacott's. In 1804, Robert Westacott took over the firm of John Wilkey, which then became J. & R. Westacott a few years later. By 1817 the firm was producing brigantines, schooners and sloops, which were being ordered from London, Liverpool and Wales. Originally situated at the end of Taw Vale Parade (roughly where Rock Park now is), this restricted the scope of the work carried out as no vessel could be built that could not pass under the arches of the Long Bridge. Eventually the shipyard was moved to the other side of the bridge (later Shapland and Petter), thus removing this restriction. The firm eventually closed down in the early 1900s, largely owing to the increased use of iron in shipbuilding.

Percy Westacott, great-great-grandson of John, was tasked by the government to build reinforced-concrete ships at the beginning of First World War, and so returned to Barnstaple. The town was chosen for this task due to its ideal position on the river estuary and the excellent railway links, as well as the reputation of Westacott's.

## Wyatt, Adam

Barnstaple town clerk from 1586 to 1611, Adam Wyatt (sometimes spelt Wyote or Wyats) kept diaries covering these years. There are several versions of the diaries over the centuries, but the most detailed copy was discovered in 1998 in the Somerset Record Office in Taunton. It was a copy of the original manuscript made by Revd John Hanmer in the mid-seventeenth century. As a result of this Dr Todd Grey published *The Lost Chronicle of Barnstaple,* an important and fascinating source of research for this period.

Ornate frieze above a High Street shop.

## X-Ray Machine

In 1864, Dr Joseph Harper went into partnership with Dr Charles Morgan and opened a doctor's surgery in Bear Street, making it the oldest in Barnstaple. In the late 1930s an X-ray machine was introduced into the practice – the first in the area. The practice moved to a purpose-built health centre in Vicarage Street in 1975.

# Y

## Yarn Beam

The Yarn Beam on the quay was where yarn was officially weighed before being sold, for which fees were payable. It fell out of use in the eighteenth century as woollen manufacture declined and there were various disputes as to the payments.

## Yeo

Barnstaple's second river, the Yeo, is often forgotten but was historically more important. Also, like the Taw, it flowed over a wider area surrounded by marshes. The boundary between Barnstaple and Pilton lies in the bed of the Yeo, so until the nineteenth century the obligation to maintain the causeway and bridge was shared between them. The residential district of Yeo Vale was formed early in the twentieth century with the two main roads being Yeo Vale Road and St George's Road. There are several rivers called Yeo in the South West and it is said to derive from a dialect form of Old English – 'ea' simply meaning 'river'.

## Youings, Professor Joyce

Joyce Youings was a member of the Barnstaple Youings family and was born in 1922. She became the first female professor (of English Social History) at Exeter University in 1973 and also published many books on sixteenth-century Devon. In 1989, she gave the presidential address of the Devonshire Association at Barnstaple, entitled 'Tudor Barnstaple: New Life for an Ancient Borough'. Her closing remarks seem oddly relevant today: 'England was becoming not so much a centralised state as a country dominated by London and by metropolitan interests ... in the later sixteenth century the provincial trading centres were preparing to fight for their existence. Barnstaple was well placed for she had learned long ago to steer her own course. May she continue to do so in the years ahead.'

The River Yeo, once considerably wider than it is now.

## Zenaxis, No. 7 The Strand

Zenaxis was a nightclub in the 1980s in the property on The Strand now occupied by Wetherspoon's. This building has served many purposes. In the late 1850s the merchant warehouses of Arter & Son were rebuilt to become the West of England Steam Biscuit Co., later to become the North Devon Bread & Biscuit Co. There were several problems with the business over the years and by the late 1890s the premises were shared by a cake factory owned by Mr Brooks and the offices and stores of G. T. Andrews, a manure merchant. Soon, however, Mr Brooks was running a restaurant there, which within twenty years would be taken over by Arthur Bromley. Bromley's Café and bakery, which occupied premises from The Strand to High Street, continued there for forty years and is still remembered with affection by Barumites who attended dances in the ballroom there.

Bromely's Café, remembered with great affection.

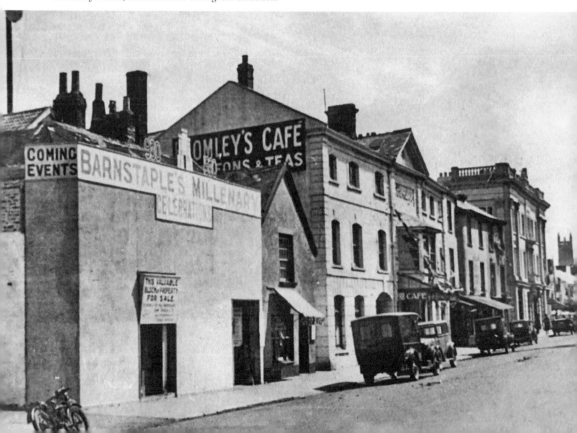